F D N Y

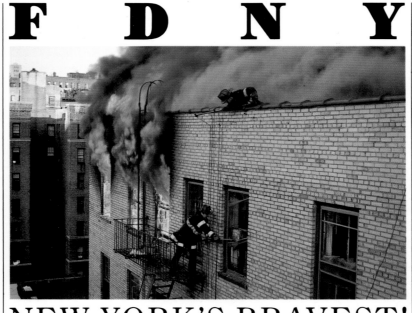

NEW YORK'S BRAVEST!

BARON WOLMAN PRESENTS

F D N Y

By
George Hall
&
Thomas K. Wanstall

Design by
Jon M. Nelson

With additional photography by
Harvey Eisner

NEW YORK'S BRAVEST!

CHRONICLE BOOKS
San Francisco

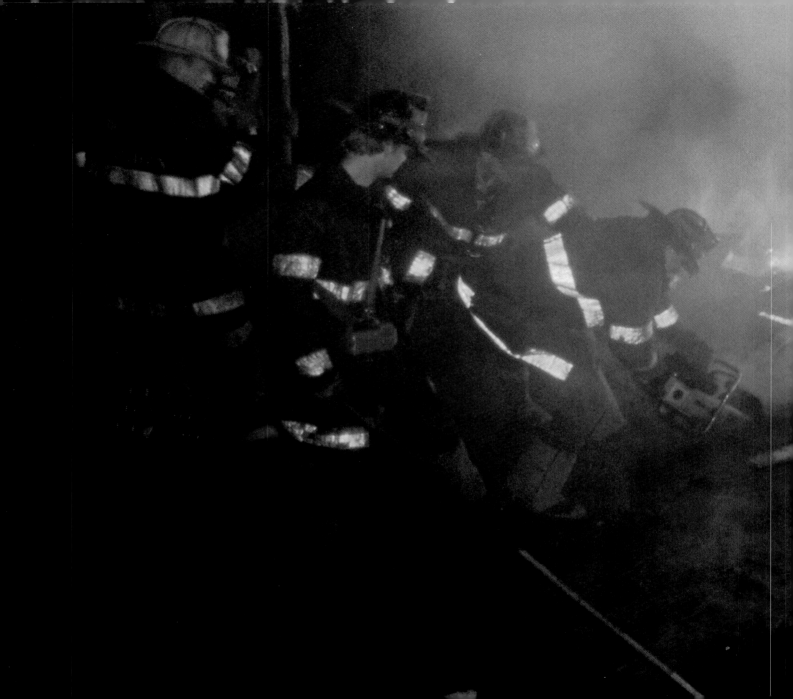

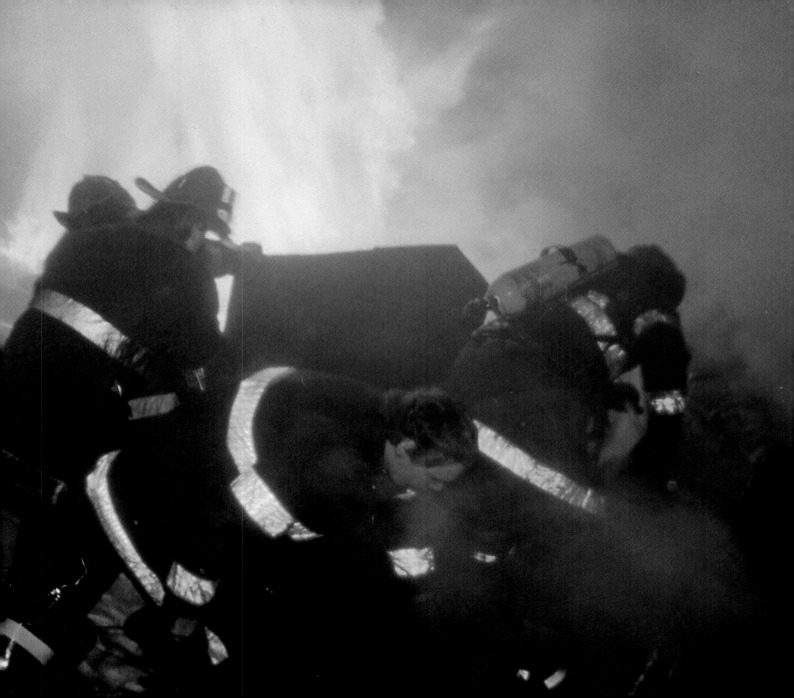

The Working Fire Series

WORKING FIRE:
THE SAN FRANCISCO FIRE DEPARTMENT
FIRE IN FOCUS: AN ACTION PORTFOLIO
FDNY: NEW YORK'S BRAVEST

Published by Baron Wolman/SQUAREBOOKS

Copyright © 1984 by Squarebooks, Inc.

Photographs individually copyright © 1984 by
Thomas K. Wanstall, George Hall, Harvey Eisner, Jeff Smith, Robert Carpenter
and/or Alan Ampolsk

Text copyright © 1984 by George N. Hall

Library of Congress Cataloging in Publication Data

Additional photography: p. 82: Alan Ampolsk; p. 27, 31 bottom right: Jack
Calderone Collection; p. 93 bottom and right, 102 left: Robert Carpenter; p. 4–5,
45, 65, 99: Jeffrey Smith; p. 32: FDNY Photo Unit

Edited by Elena Serocki, Tom Soter and Dianne Kushner

Typography by Mates Graphics, Montclair, New Jersey

Printed in Japan by Dai Nippon Printing Company, Ltd, Tokyo

Chronicle Books
870 Market Street
San Francisco, CA 94102

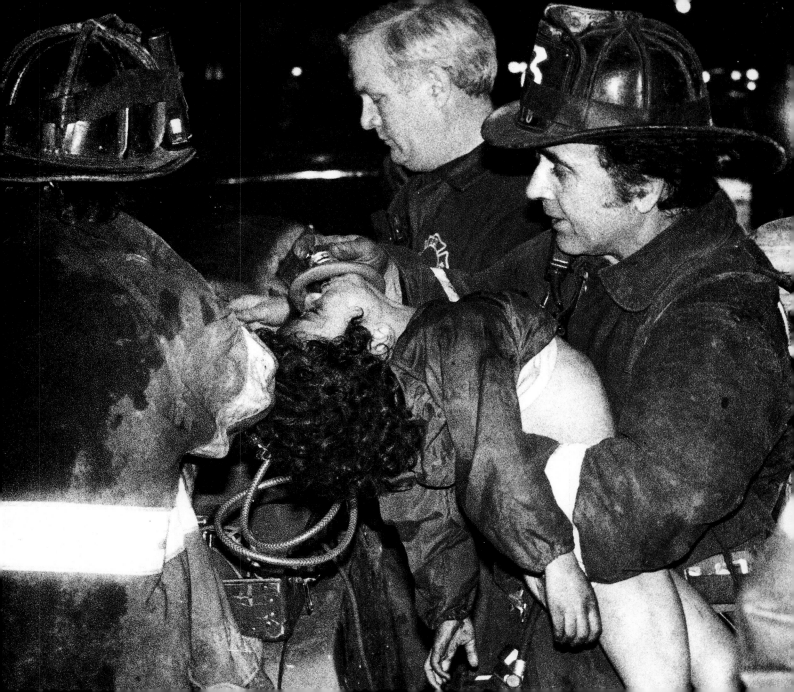

Acknowledgements

To firefighters and fire buffs alike, the New York City Fire Department—FDNY—is the big time, the major leagues, the first string. It's not uncommon for New York's Bravest to see more serious fire action in a single work tour than other firefighters catch in months.

We've both followed big-city fire action for years—in Yonkers, a New York suburb that sees far more than its share of big workers, and in San Francisco, last of the traditional fire departments in the West. In 1982, we decided to team up on the story of the FDNY— its history, its traditions, its apparatus, its techniques, its people. We hoped to illustrate in words and pictures the skill, experience and dedication of New York's firefighters.

If we've succeeded, it's due to the unfailing cooperation and openness we encountered on every level of the department, from Commissioner Joe Spinnato and Chief of Department John O'Rourke down to the newest "probie"—probationary fireman—on the job. We chased down hundreds of alarms, and

we stayed to ride with companies in all five boroughs. We were privileged to share firsthand the lows and highs of America's most dangerous profession. We took in everything: the nuisance calls, the appalling discomfort that comes of mixing water and winter, the panicky claustrophobia of a smoke-charged fire room, the incessant and maddening false alarms. We also caught the guilty exhilaration of rounding the last corner en route to the box and catching sight of flame billowing from a dozen windows. Ride with New York's Bravest, and you'll see it all.

Nevertheless, although we're both pretty fair fire photographers, we were unable to be everywhere at once. There were often several major blazes working around the boroughs at the same time, and too often we would arrive on the scene to find nothing but steam, ashes and overhauling—the FDNY hits fires fast and hard. So we're indebted to several of New York's best fireshooters, especially Harvey Eisner, Jeff Smith and Bobby Carpenter, for access to their

most dramatic shots. Without their contribution, our telling of the FDNY story would have been far less compelling.

Fire stations everywhere are traditionally homes away from home. Firefighters spend great amounts of time living together, and it is normal for the firehouse to be a closed and insular society. We have visited perhaps a hundred fire departments around the world in our capacity as correspondents for *Firehouse Magazine*, and nowhere have we been as openly and graciously tolerated as in New York. It seemed that we were on the rigs and in for the evening meal almost before we knew it. And precious little prompting was needed to get the war stories flowing. Many were told, and none were boring.

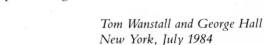

For their patience while being subjected to interviews and interruptions, we offer special thanks to Assistant Commissioner John Mulligan; Chiefs Lou Harris, Vinnie Dunn, Joe Mills and Bill Shaw; John Regan and Matty Conlon of the Marshals, along with the Harlem Red Caps; and the head

guys at the shops, Tom Halford and Tony Romagnoli. We also received continuing and cheerful assistance from Rescue 3's Jack Calderone, Ken Fisher of the Brooklyn Communications Office and Honorary Deputy Chief Joe Pinto.

There isn't room to name all the firefighting companies that helped in the preparation of this book, but here is a nod to the outfits we bothered the most: in Brooklyn, 248 Engine and 281 Engine/147 Truck; in Queens, 126 Truck; in the Bronx, 88 Engine/38 Truck, 75 Engine/33 Truck and 45 Engine/58 Truck; and in Manhattan, 58 Engine/26 Truck, 69 Engine/28 Truck and 93 Engine/45 Truck/Rescue 3. Their enthusiastic outpouring of information and anecdotes, as well as their willingness to let us tag along to the box, made the book possible. The authors reserve for themselves credit for any errors that may have slipped past their guides and mentors.

Tom Wanstall and George Hall
New York, July 1984

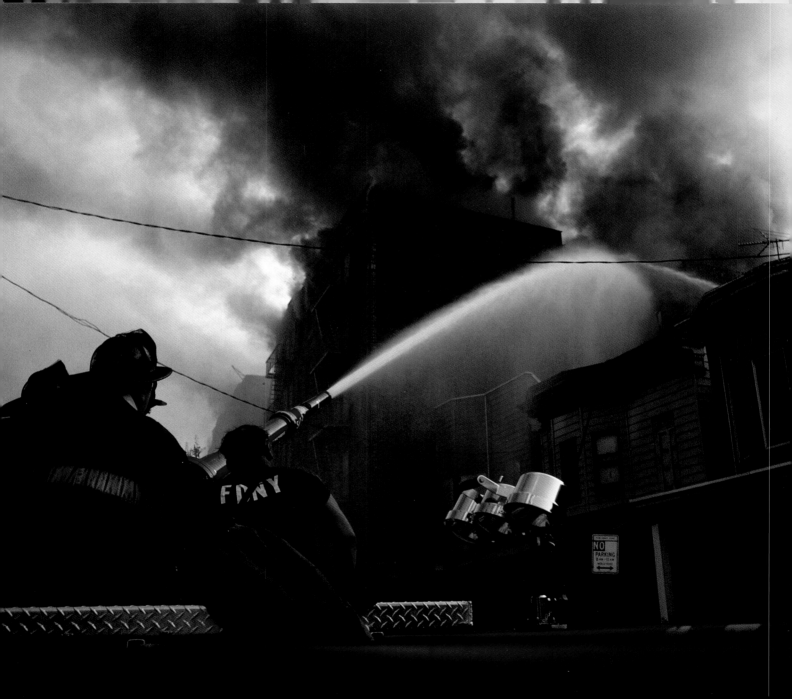

All Hands

Good-news-and-bad-news time. The good news was that the two foremost chefs in the house were combining their talents on beef Wellington for a dinner sitting of 15. The bad news had to do with an old firehouse superstition: cook a wonderful meal, and it will wind up being eaten, cold and glutinous, at two in the morning. The big fire, the "jobs," have a perverse tendency to land squarely atop the chefs' best efforts.

True to form, the box came in after about three tantalizing mouthfuls. A series of electronic tones, three sharp rings on the house bell, a shout from the man on watch in his booth between the rising vehicle doors: "Get out everybody, engine, truck and chief, first-due, phone alarm." Firefighters

Satellite deck gun throws thousands of gallons of water into a blazing vacant building in the Bronx.

kicked off street shoes and climbed into knee-high boots, heavy Nomex turnout coats reeking of a thousand smoke-charged rooms, and ravaged whale-tail leather helmets festooned with wooden doorstops and tiny flashlights.

Key crew members slung Motorola portable radios across their chests like bandoliers. The officers studied their computer printouts, giving them the box address and assignment, before stepping up onto their shotgun seats. In seconds, the big Seagrave rear-mount ladder truck was turning left out the door into strangely indifferent traffic, the Mack pumper and the battalion chief's station wagon tucked in behind.

Everyone caught the smell immediately—tenement smoke. The probie, on the job only three months and still excited by the prospect of facing the "Red Devil," whooped and yelled in the crew cab like a rodeo cowboy. Older and

more blasé members busied themselves fastening coat clasps, buttoning up collars, pulling on fireproof gloves. The lieutenant crammed the radio handset to his ear, waiting for further information. His booted feet worked the siren and airhorn controls like organ pedals. The rig blasted through another red light, the chauffeur whistling tonelessly. Good smoke now, and another block to go.

Around the last corner, and into a wall of dense brown smoke. The truck crept ahead blindly as the lieutenant keyed his mike to transmit a "10-75" working fire, to fill out the first-alarm assignment. A fleeting hole in the smoke revealed gouts of ominous orange flame in a window, and two petrified humans in the window above. An arson job, of course—too much fire too soon.

It would be an inside job, quick and dirty. Everyone knew the drill: stretch one and possibly two hose-lines into the fire rooms, put truckmen on the floor above to look for fire upstairs, search the whole building—every room—for people trapped or unconscious. Check the adjoining buildings for possible fire extension, open the windows and roof for ventilation, tear the fire rooms apart to make sure no hot spots remain.

The rough stuff was over in minutes. Fire knocked down by hand-lines, held to three rooms and the hall stairway where it started. Two tenants rescued by aerial ladder, the others escorted down fire escapes and the rear stairs. A quick vent hole cut in the roof when forcing the bulkhead door proved too time-consuming. One dog revived by blasts of air from a truckman's Scott mask. Two firefighters hurt—an engine officer with an ankle sprained on the ruined interior stairs, a chief's aide with a deep gash from a falling shard of glass. Red-capped fire marshals struggled for order as they interviewed enraged tenants.

Two hours of overhauling would follow: pulling ceilings and walls with hooks and pry bars, removing ruined furniture to the curb, doing a quickie patch job on the three-

A row of commercial "taxpayer" storefronts in the Bronx is ravaged in a third-alarm blaze.

foot hole in the roof. No sweat—dinner by 11 P.M. easy. Could have been a lot worse.

The New York City Fire Department does this sort of thing a lot—out the door a thousand times a day, more or less, for everything from false to fifth alarms.

The numbers are stunning. Firefighting force: over 12,000. Population served: 8 million, more with the day's commuters. Area covered: 312 square miles and 600 miles of waterfront. Buildings protected: 825,000, including 1000 high-rise, 10,000 abandoned. Number of units: 212 engines, 140 ladder trucks, 5 heavy rescues and hundreds of support vehicles, all arrayed into 12 divisions and 54 battalions. Total alarms: 350,000 a year.

The Fire Department of the City of New York is without question the busiest and most experienced firefighting force in the world. There are departments with greater manpower (Tokyo), departments that protect more structures (Mexico City), departments that cover larger geographical areas (Los Angeles County). But no fire department anywhere does the work of the FDNY. *Firehouse Magazine* recently compiled its annual list of America's busiest fire companies. In 1983, 47 of New York's trucks made more runs than the busiest truck from any other de-

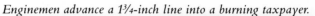
Enginemen advance a 1¾-inch line into a burning taxpayer.

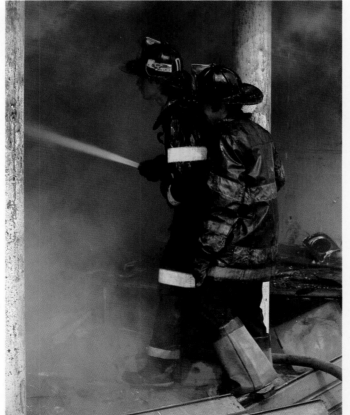

partment in the country (Newark, New Jersey).

There are fire departments everywhere that are trained thoroughly, equipped impressively and manned by dedicated and courageous firefighters. They just don't get the fires, or, as they say in New York, the "jobs." New York's large population is only a partial explanation. There are big cities like Zurich—with a million people in the metropolitan area, structures hundreds of years old and a bitter winter—that don't have even one-hundredth of the fires that New York suffers. Or Tokyo—even bigger than the Apple, dense and flammable in the extreme—with perhaps a fifth of New York's alarms. Of course, few cities share the complex mix of economic, social and political elements that make up America's largest city.

What does New York have that they lack? Arson, for one thing—8000 suspicious fires in 1983, a figure that has *dropped* in recent years. Unforgiveable carelessness picks up where arson leaves off; for every arson-related death in 1983 (36), there were more than two (73) caused by people who insist on smoking in bed. Electrical fires in that year killed 48 New Yorkers, and 25 children died while playing with matches or candles.

And then there are the false alarms, 380 a day on the average. Large cities like

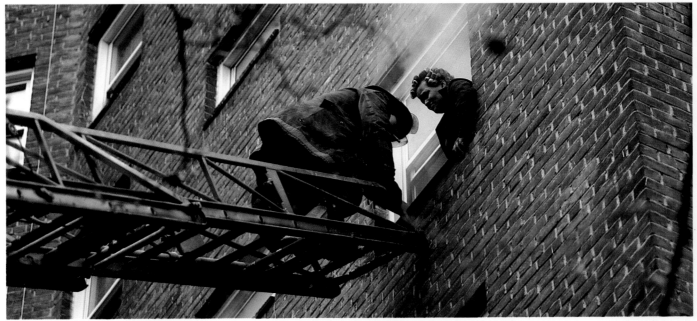

Truckman of Ladder 23 comes to the rescue of a Harlem housing project resident.

Rome and Stockholm have fewer false alarms in a *year*. Most in New York originate from older manual pull boxes, apparently a tempting target for school kids and neighborhood punks with nothing better to do. A surprising number come in by phone and over the newer ERS (Emergency Reporting System) boxes, which enable the box-puller to talk with the fire dispatcher. It's an expensive, dangerous and morale-shattering problem that refuses to dissipate. The term "false alarm" can scarcely be translated into Japanese, so foreign is the notion.

But the FDNY always, always responds. It's a source of stubborn pride: you don't let the bastards grind you down. "People count on us, and the word's been out for years that you can always count on the firemen to show up," says Bronx veteran Pat Connolly. "They call us instead of the cops, or Con Ed, or the ambulance, or the Welfare. Es-

pecially in the really lousy neighborhoods. We get in on family disputes, landlord hassles; the guy's bathtub upstairs is running over, some 400-pound lady falls out of bed and has to be helped up. Don't laugh—just had that one the other day.

"They abuse our services, sure. But it's rough out there, in case you haven't noticed, and who else is going to come and help? Sometimes it's just old people with some made-up problem—they're lonely and scared. But the word's out, even if you just got off the boat yesterday—you got trouble, call the fire department, and in three minutes you'll have all these big guys with axes. And you know what? It's true."

The job is a calling, and the firefighters love their work. They show up early for the twice-daily shift changes (9 A.M. and 6 P.M., a rotating combination of 9- and 15-hour shifts), and they stay late, sitting around Formica dining tables to

rehash the jobs of the last tour. Their sense of humor is uproarious and utterly tasteless, often bewildering to outsiders and newcomers on the job. Nothing—but nothing—is sacred in the firehouse—not your race, your gender, your mother, your wife, your kids. Not even your fellow firefighter who's in the burn ward after going through the roof at last night's job. Everyone and everything is hammered mercilessly, to the endless delight of all. No one can hold a "roast" like a roomful of firemen; the whole idea was probably their aptly named invention. Even the officers take their share of the heat.

Each company—engine, ladder, rescue or whatever—is commanded by a lieutenant or a captain; in stations with two or more rigs, the senior captain is also head man of the house. Com-

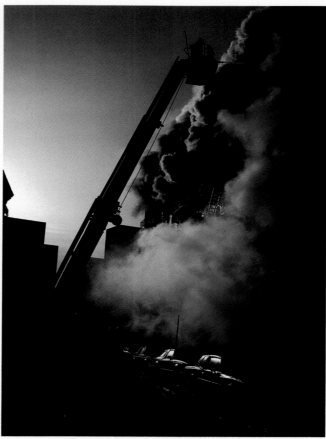

Five alarms in a row of Harlem tenements.

line: first as a "johnny," or probationary fireman, then as a working stiff for at least several years before passing his first promotion exam. Unlike bosses in most other professions, he doesn't retreat to a desk to supervise his people. He remains on the front lines of the never-ending battle, often the first person into the fire building and the last out. Even battalion and division chiefs, the bird colonels and generals of the firefight, are seen emerging red-eyed and snot-nosed from ruined structures, their white uniform shirts fouled beyond hope. In the 1966 building collapse that resulted in the worst firefighter death toll in FDNY history, two chiefs and two company officers plunged to their deaths along with eight of their fellow firefighters as they sought the seat of the fire.

panies in a geographical district are organized into battalions with a chief in charge. The battalions in turn are grouped into divisions with higher-ranking chiefs commanding. Above that level are the borough commands, with the top brass plus civilian commissioners at the Livingston Street, Brooklyn, headquarters.

E very FDNY officer, from the apple-cheeked lieutenant to the Chief of Department, is a former man-on-the-

N ew York firefighters love and care for their troubled city, much as they jokingly insist to the contrary. Most are New York natives and many are the children of firefighters, as are their spouses. Even the youngest remember a sweeter and safer New York, and they're proud to be doing more than most of their fellow citizens to hold back the tide

Apparatus jam the streets at the four-alarm Hotel Gregory fire. Bright sunlight belies near-zero temperatures.

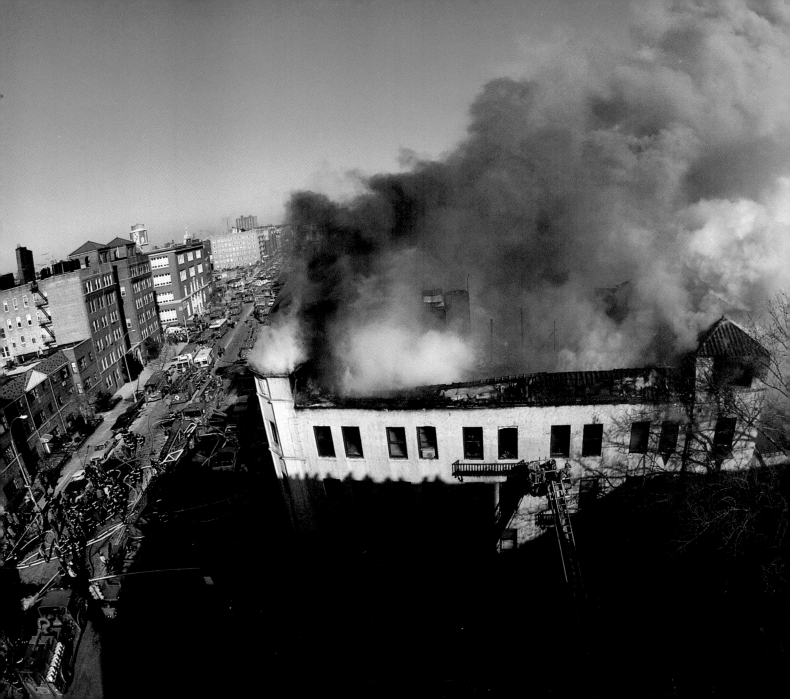

of danger and devastation. Says long-time Bronx Battalion Chief Tony Novello: "We lose some battles, sure. But we win a few, too. There are some awful mutts living here, but most of these people are really OK, and they're trying hard to make it. That's the best thing about the job—not a day goes by that you don't help somebody out."

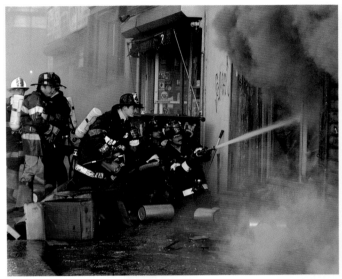

(Above) *Firefighters of the Fourteenth Battalion put the first hose-line into operation at a fire in an auto parts store in the South Bronx.*

(Left) *A top-floor apartment on the left side of an H-type apartment building is well involved, with fire that has also burned into the cockloft. Quick teamwork between the engine companies moving in with hand-lines and the truck companies pulling ceilings and cutting the roof stopped the fire before it reached multiple-alarm proportions.*

(Right) *Roofman from Rescue 3 uses a power saw to open up the roof directly over the fire.*

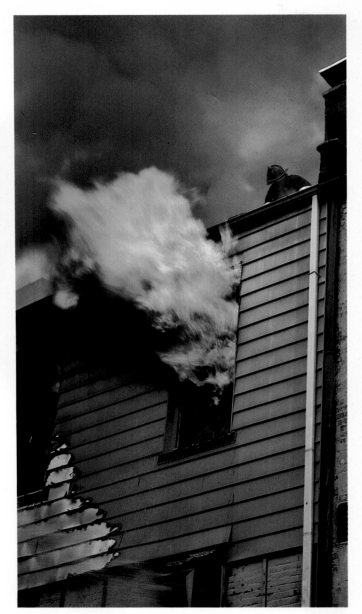

Fire in Gotham

A Compact History

In 1664, when the tiny Dutch colony of New Amsterdam became the British settlement called New York, organized firefighting was limited to sporadic evening patrols and a collection of 250 leather buckets kept filled with water. The first evidence of serious fire suppression efforts came in 1731 with the arrival of two Newsham hand-drawn pumpers from London. Citizens were urged to respond to all alarms and man these tiny pumps. The machines put forth a meager stream similar to a garden hose of today, but at least they provided a continuous spray as long as volunteers worked the seesawing pump handles.

The actual organization of the Volunteer Fire Department of the City of New York was decreed by the General Assem-

Nathaniel Currier, a New York firefighter himself, posed for this 1880 Currier & Ives lithograph.

bly in 1737, the call going forth for "able, discreet, and sober men" to stand ready for service day and night. But the volunteers' zeal was matched neither by equipment nor by knowledge, and structure fires routinely burst forth to consume whole blocks. A large portion of the city was lost in a 1776 conflagration, and most of the city's burgeoning business district was destroyed by fire in 1835. The "vollies" were left helpless in the face of this blaze; they confronted bitter winds with a temperature of -17 degrees Fahrenheit, and their pumps and cisterns were hopelessly frozen. An 1845 warehouse explosion touched off 300 commercial buildings, and in a particularly horrible chain of events six years later, a false alarm in a Greenwich Village school led to the deaths of 41 children in a panicky stampede from the building. Organized school fire drills were an outgrowth of what was probably history's most catastrophic false alarm.

But the volunteers were learning to fight fires, and their hand pumpers were becoming ever more potent and numerous. In 1853, a large fire in several buildings used by *Harper's Magazine* was successfully checked with lots of water and skillful venting or opening of the roofs. The firefighters were now being aided by the newly completed Croton Aqueduct, which provided impressive amounts of water for their operations.

The size, social clout and raw political power of the volunteer companies had expanded enormously by the mid-nineteenth century. The era of the Tammany Hall political machine was dawning, and the New York vollies were an integral part of its momentum. In fact, the notorious William "Boss" Tweed, soon to become the ultimate Tammany kingfish, was a respected volunteer firefighter himself, fighting many a blaze as foreman (captain) of the "Big Six" engine company. The rambunctiousness of the period frequently resulted in rivalry, dirty tricks and outright pitched

15 ENGINE CO. 15

Boss Tweed's volunteer company once occupied the quarters of present-day 15 Engine on the Lower East Side.

battles among the 50 or so volunteer outfits. Unfortunately, the actual firefighting and rescue work often took a back seat to the shenanigans. These antics, plus the onrush of industrial technology, spelled impending doom for the city's volunteer forces.

Cincinnati's Latta brothers visited New York in 1859, promoting their small steam-powered fire pumper. The Lattas invited the Gotham volunteers to meet them in front of City Hall with their most efficient hand engine. The vollies gave the nod to the men of Northern Liberty Engine 42, who ran with a colossal rig known around town as the "Man Killer." Its four sets of "brakes," or lateral pump handles, could accommodate 60 men; naturally the biggest, youngest and strongest were called upon to put the steam-

The 1835 Wall Street conflagration leveled 20 acres in the commercial district.

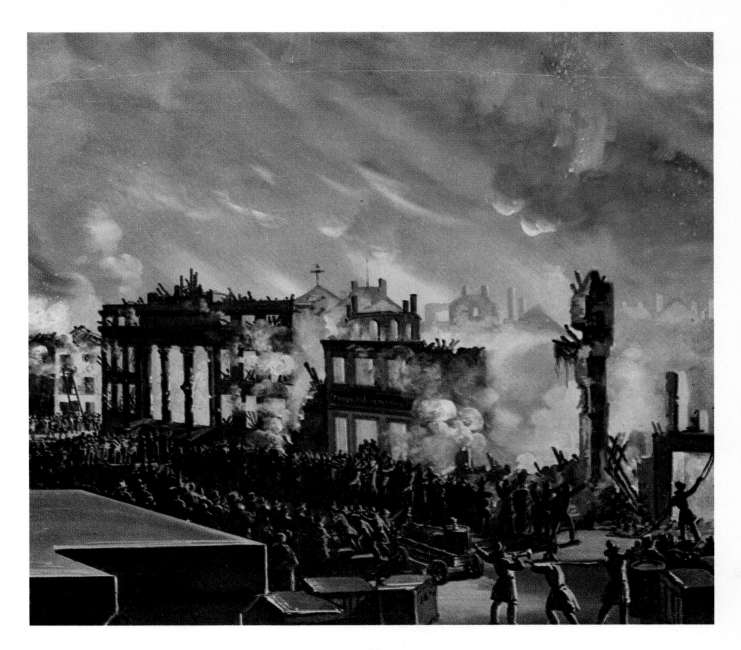

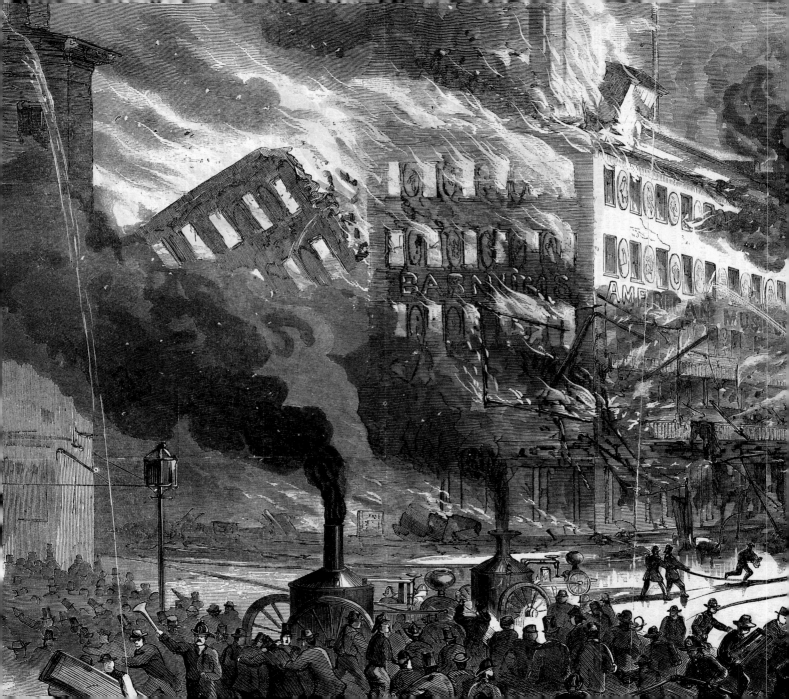

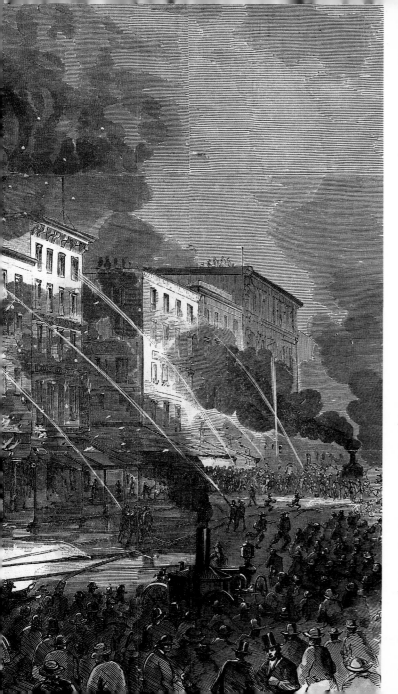

powered upstart in its ignominious place. With superhuman effort, the "bhoys" (sic) of 42 Engine succeeded in throwing their stream farther and higher, by a few feet, than the little Latta machine. However, after only a few minutes of back-breaking toil, the cream of the New York firefighting force lay panting on the City Hall lawn. And although the steamer's throw had been bested, it continued to huff merrily along, with only an occasional tweak of the controls. It was clear to all that the vollies' victory was meaningless, that steam power was the wave of the future.

The steam apparatus eliminated the need for platoons of men to pump the brakes, and horses soon took over the chore of pulling the heavy rigs through the streets. Business and insurance interests, fed up with the fun-loving volunteers and their often sporadic performance, agitated for a paid professional fire department in New York.

The year was 1861, and the Gotham volunteers were about to go out with a tragic flourish. With the outbreak of the Civil War, New York firefighters quickly formed the Union's first volunteer military outfit, the First Fire Zouaves. Outfitted in colorful red-panted, French-style uniforms, they marched off to the south, 1100 strong. The Zouaves soon saw action at Bull Run, but their enthusiasm was not matched by any real training or experience in soldiering. They suffered terrible casualties and returned to their hometown three months later with only a quarter of their original strength.

The Second Fire Zouaves reentered the fray two years later, again taking heavy losses in the climactic Battle of Gettysburg, while even their firefighting companions at home found aspects of the war extending into their own front yards. For by 1863, President Abraham Lincoln had been forced to institute a highly unpopular military draft, made all the more unpalatable by a loophole which permitted men of means to buy their way out of the war by hiring

Gotham vollies and new paid professional firefighters combined their efforts at the huge Barnum's Circus Museum fire, 1865.

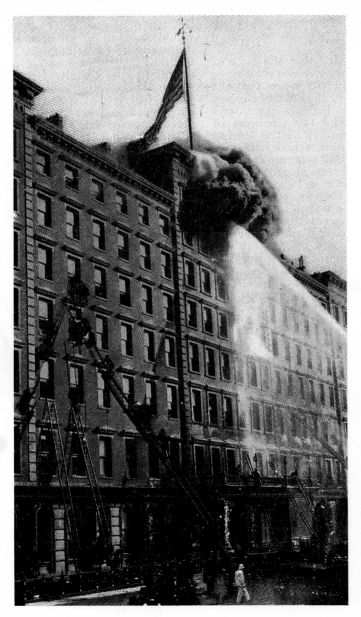

substitutes. On July 13, 1863, an anti-draft mob began gathering ominous force, with arson a principal weapon of their rage. Draft offices, military armories and police headquarters on Mulberry Street were set alight, and the vollies were fiercely attacked when they attempted to put out the blazes.

At one point, while leading firefighters at the torched Colored Orphans' Home, the volunteers' popular chief, John Decker, was beaten unconscious and nearly lynched from a nearby tree. As the chief came to, a tightening rope around his neck, he croaked to the mob, "This will only stop *my* draft, not the government's!" The amused crowd released the chief, but it was one of the few moments of levity in a spate of horrible madness.

With increasing violence, riots raged day and night for a week, ultimately leading to 1200 deaths and thousands of injuries to police, firefighters, soldiers and hapless blacks. The New York Draft Riots remain by far the most bloody civil disturbance in the nation's history.

The end of the Civil War coincided with the establishment of a paid New York–Brooklyn Metropolitan Fire Department (Brooklyn was still a separate city with its own large force of volunteers). The volunteers and their Tammany friends vainly fought this move both politically and legally. Their antagonism was soothed somewhat by a policy which gave hiring precedence to former New York vollies. When mustered out, the volunteers turned over 52 engines, 54 hose wagons and 17 ladder rigs to the city.

New York was now grandly referring to itself as the "Third City of Christendom," with an urban population approaching 2 million. The new department fielded 33 engines and 11 ladder rigs in 1865, with each engine and truck company containing 12 men. Six hundred paid firefighters worked continuously, with one day off *per month* and three free hours a day for meals at home. Regulations prohibited

The Windsor Hotel fire claimed 92 lives on St. Patrick's Day, 1899. Firefighters had to fight fire and paradegoers.

drinking, profanity and racing other companies to fires; most members were even enjoined from riding the apparatus, being required instead to run alongside to the box! In return, a full-time New York firefighter was paid the handsome sum of $700 per year.

Professional firefighting came into its own during the latter part of the nineteenth century. The department purchased mighty Amoskeag horse-drawn steamers in "first-size" and "second-size" configurations. The largest of these impressive machines could throw over 1000 gallons of water per minute for hours on end — no less than today's FDNY engines — allowing firefighters to attack fires with truly serious water power for the first time in history. Self-erecting aerial ladders also came into service. In 1898, consolidation merged Brooklyn, Queens, Richmond (today's Staten Island) and the remainder of the Bronx into greater New

A 1909 Combination Ladder Company high-pressure hose wagon responds near the Battery.

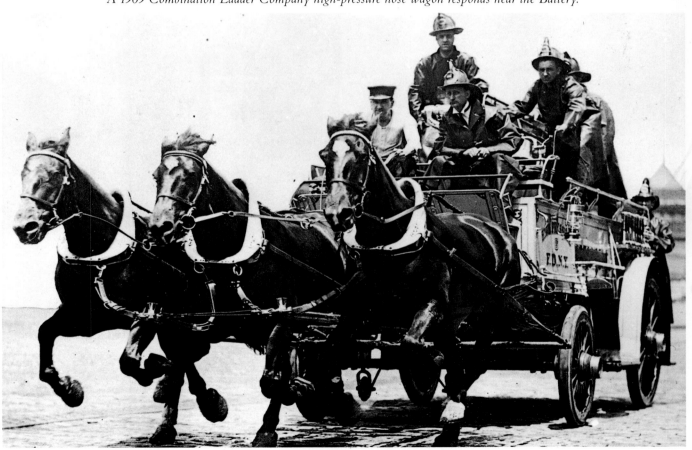

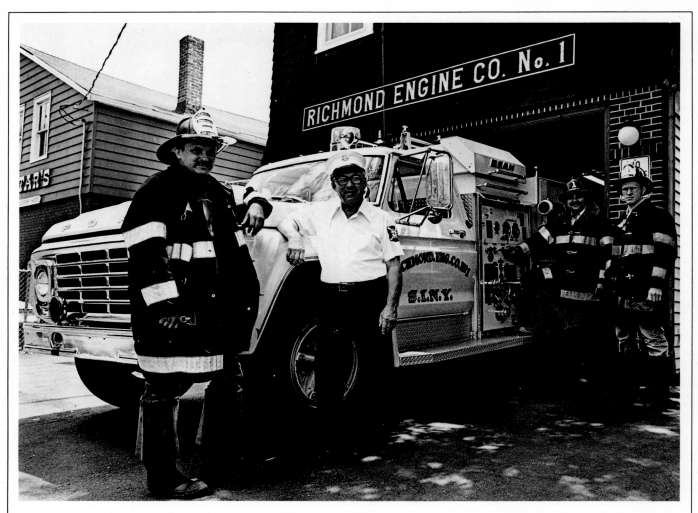

*I*t comes as a surprise to many that the FDNY still relies on the assistance of several volunteer companies in the Bronx, Queens and Staten Island. Richmond Engine Company No. 1 and another Staten Island outfit operate by authority of a special New York City charter dating from 1904. Its members are summoned to fire scenes by the fire dispatchers on the island, using both radio and direct telephone contact. The traditional vollie signal, a siren atop the house, is also sounded as a backup alarm. There are currently 10 volunteer companies located throughout the city, in every borough except Manhattan.

York City, adding 250 square miles and 1.5 million citizens. Brooklyn's unique two-tone green rigs were repainted FDNY red, and department membership swelled to 4000.

In 1904, two radical experiments were attempted. Although full adoption was delayed for 15 years, a two-platoon system with a liberating 84-hour work week was tested in Manhattan houses. (The trend toward more humane working hours continued with eight-hour days in 1937 and the 40-hour week in 1956.) Also in 1904, the department purchased two American Mercedes automobiles, its first motorized apparatus, for Commissioner Hayes and Chief of Department Croker.

Motorization continued at a steady pace, with the versatile two-wheel Christie gasoline tractor assigned to pull the still-dependable steamers. Horses made their final official run to a Brooklyn box in 1922; the steamers themselves remained on the job until 1933. "Reformed" fire horses — strong, smart and spirited in their adulthood — were famous for racing to fire scenes pulling milk wagons or delivery vans, their new owners running frantically behind. Surprisingly, response times today are not substantially faster than they were in horse-drawn days. In a 1910 demonstration for visiting European royalty, an engine was manned, hitched to its three-horse team, driven four blocks to a hydrant, and was spewing out a stream in two minutes, 35 seconds.

New York's professional department has fought an incredible variety of lethal fires in its 120-year history; it is doubtful that any other firefighting force in the world has faced such a gamut of bizarre and appalling situations. Some of the most memorable incidents include the 1865 Barnum's Circus Museum fire (where volunteer and paid firefighters worked side by side) which required the rescue of terrified jungle beasts from the inferno; the 1904 *General Slocum* disaster, which saw the deaths of over 1000 picnickers as the antiquated cruise ship burned in the East River; the 1911 Triangle Shirtwaist Factory fire on the lower East Side, in which 146 young seamstresses perished as they leapt from tenth-floor sweatshop windows; the 1922 Arverne or Rockaway conflagration, which saw hundreds of flimsy vacation homes consumed in a fire storm; the 1922 Jane Street com-

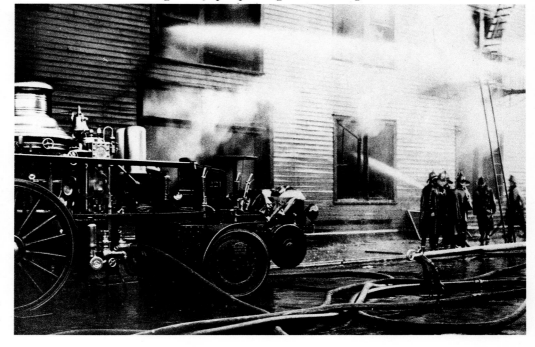

A motorized Amoskeag steamer pumps a huge stream through a handheld line in 1915.

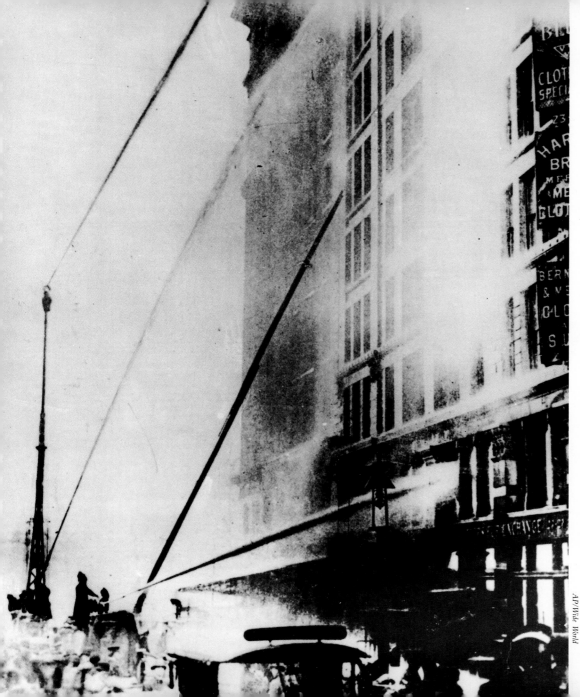

Firefighters pour water on the blazing Triangle Shirtwaist Factory in 1911.

mercial blaze (also known as the "Greenwich Village Volcano"), which caused the deaths of two firefighters and hurled debris into the air for three days; a 1935 seven-alarm fire in a Furman Street, Brooklyn, warehouse that burned for five days and felled more than 1000 firefighters who inhaled smoke from 2 million pounds of burning crude rubber; the 1945 crash of a B-25 bomber into the fog-obscured Empire State Building; and, in 1960, the stubborn fire aboard the aircraft carrier U.S.S. *Constellation,* which raged below decks as the huge ship was docked in Brooklyn.

No fire touched the New York Department more deeply than a seemingly routine box on West 23rd Street in 1966. Firefighters searching for the seat of a lurking fire in a drugstore were suddenly plunged into a basement inferno when the floor collapsed. Twelve firefighters died in this tragic incident—

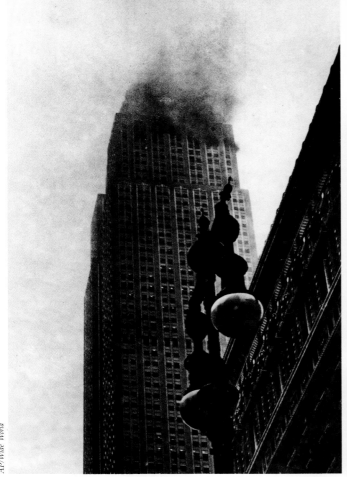

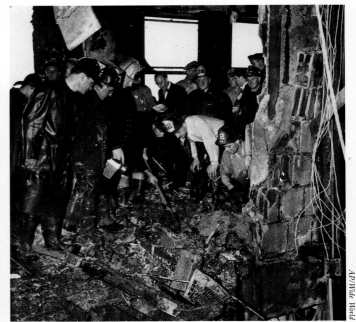

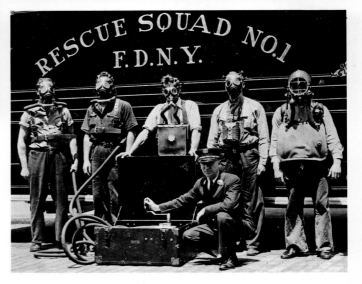

(Above and upper right) *On July 28, 1945, an Army B-25 crashed into the Empire State Building, killing 14 people and injuring 26 others. The fire department had to battle the fire 915 feet above the street. Firefighters used 15 hand-lines to extinguish this intense gasoline-fed fire following the crash. One of the plane's two engines plunged into the elevator shaft and plummeted 1000 feet down into the subbasement.*

(Right) *Members of Rescue Squad No. 1 demonstrate the different styles of breathing apparatus carried on these rigs.*

the greatest loss of life in FDNY history.

The decade of the seventies saw perhaps the most horrifying orgy of fire in New York history — a reign of a hundred thousand arson fires that nearly obliterated square miles of the South Bronx, East New York-Brownsville, Bushwick and Harlem. Today, thousands of burned-out "vacants" remain, blighting the city and attracting more incendiary fires. The worst of this epidemic is now over and annual fire totals are dipping to levels of earlier years. But although the FDNY's job is quieting down, the potential for the big burner is always there. An ambiguous but ominous plaque hangs over the dining table in many a New York firehouse: THIS COULD BE THE NIGHT. Here and elsewhere, firefighting will doubtless remain the nation's most dangerous profession for years to come.

The West 23rd Street fire in 1966. (Left) *Men of 18 Engine remove body of fallen comrade.* (Right) *A memorial to the victims in the Church of St. John the Divine.*

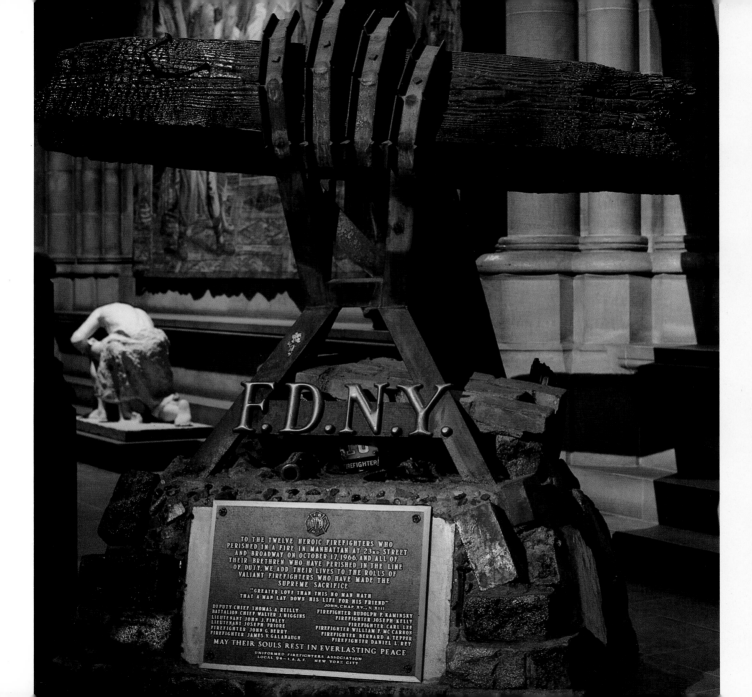

F.D.N.Y.

TO THE TWELVE HEROIC FIREFIGHTERS WHO
PERISHED IN A FIRE IN MANHATTAN AT 23ʳᵈ STREET
AND BROADWAY ON OCTOBER 17, 1966, AND ALL OF
THEIR BRETHREN WHO HAVE PERISHED IN THE LINE
OF DUTY, WE ADD THEIR LIVES TO THE ROLLS OF
VALIANT FIREFIGHTERS WHO HAVE MADE THE
SUPREME SACRIFICE

"GREATER LOVE THAN THIS NO MAN HATH
THAT A MAN LAY DOWN HIS LIFE FOR HIS FRIEND"
JOHN, CHAP. XV., V. XIII

DEPUTY CHIEF THOMAS A. REILLY
BATTALION CHIEF WALTER J. HIGGINS
LIEUTENANT JOHN J. FINLEY
LIEUTENANT JOSEPH PRIORE
FIREFIGHTER JOHN G. BERRY
FIREFIGHTER JAMES V. GALANAUGH

FIREFIGHTER RUDOLPH F. KAMINSKY
FIREFIGHTER JOSEPH KELLY
FIREFIGHTER CARL LEE
FIREFIGHTER WILLIAM F. McCARRON
FIREFIGHTER BERNARD A. TEPPER
FIREFIGHTER DANIEL L. REY

MAY THEIR SOULS REST IN EVERLASTING PEACE

UNIFORMED FIREFIGHTERS ASSOCIATION
LOCAL 94—I.A.A.F. NEW YORK CITY

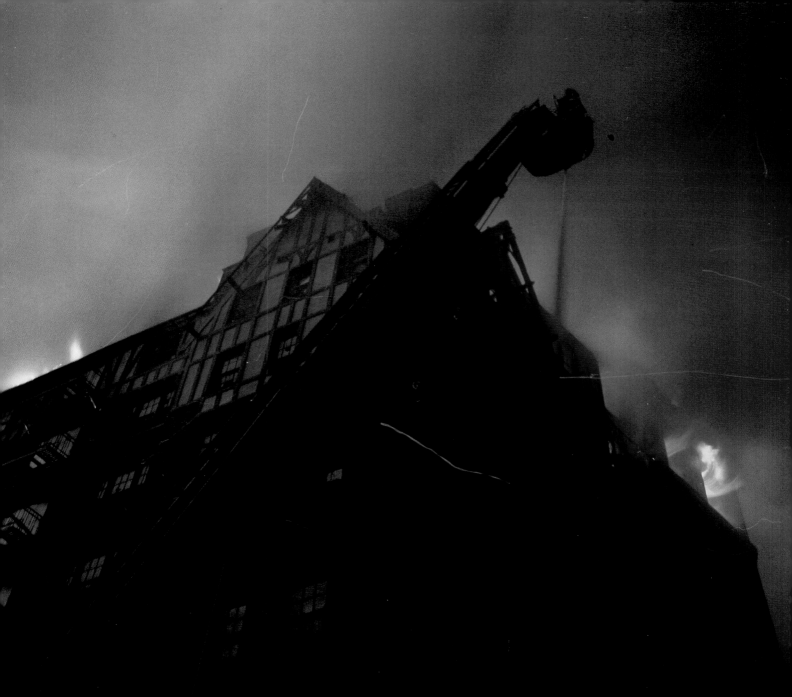

S.O.P.

The basics of firefighting are simple and universal. We remember the rules of fire from junior high science class and the candle in the Mason jar: combustion requires fuel, oxygen and enough heat to start the process. Eliminate any one of these elements, and the fire will die.

Fire suppression is the effort to interrupt this deadly and destructive linkage. Rule number one is timeless, unchanged since prehistory: douse the flames with water. No substance on our planet requires as much energy to raise its temperature one degree. Even when water turns to steam, its temperature (about 212 degrees Fahrenheit) remains below the flash points of most combustible materials. Water can actually attack all three of fire's elements: it can soak the

Fourth alarm in the Bronx: most of the top floor and roof of an abandoned "H" apartment is involved in flame.

fuel, separate the fire from oxygen and, most importantly, lower the ambient temperature.

FDNY pumpers can throw up to 1000 gallons of water per minute through several hose-lines, and every effort is made to get water on the flames quickly. Experience has shown that the faster the engine crew can get "the blue stuff on the red stuff," the better are the chances of saving the structure. Traditionally, the FDNY has placed maximum emphasis on getting inside the fire building and seeking out "the seat of the fire," the point of origin. Most fires, if attacked in time, will succumb rather quickly to a well-aimed blast from a smaller 1¾-inch line. If the fire gains enough headway, through delayed reporting or sheer explosive power, to hold the firefighters at bay outside, a prolonged fight with numerous "master streams," or large-volume appliances, will be needed to knock the fire down.

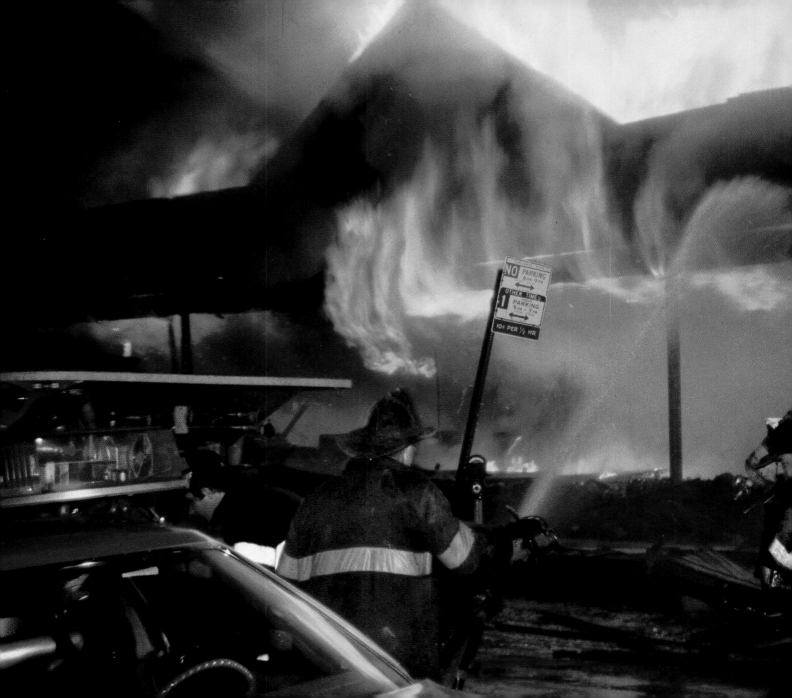

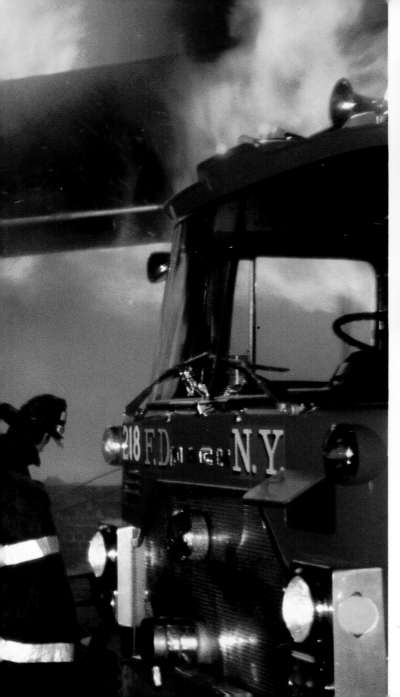

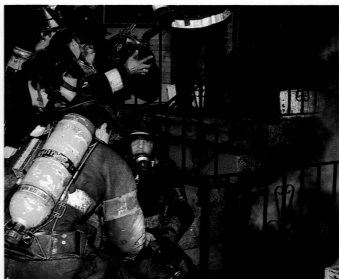

Firefighters don air mask facepieces as they wait for water before entering a burning basement apartment.

The inside attack is dangerous in the extreme, and many departments prefer to deluge their blazes from the outside. But it's not the way to wind things up expeditiously, it's not the way to save property and it's certainly not the way to save the lives of trapped or unconscious victims. "The rule is one of the first things I remember hearing on the job — the closer you can get to the seat of the fire, the sooner you're going to take up and go home," says one veteran.

A good engine crew can have water on a blaze only minutes after arriving on the scene. The rig's chauffeur is responsible for hooking up to one of New York's 90,000 hydrants, then manning the pump panel behind the cab to control water flow and pressure through one or several lines.

A vacant supermarket is found to be heavily involved by first-arriving Brooklyn companies.

Every engine also carries 500 gallons of water in a midship booster tank. This water supply is directed through a small rubber hose reel to extinguish inconsequential trash or car fires that don't require a hydrant hookup. In a drastic situation where every second is critical, the MPO (the chauffeur becomes the Motor Pump Operator at the fire scene) can dump the booster water into the 1¾-inch attack line, giving the company instant juice — about three minutes' worth — while he hustles to get onto hydrant water. This is strictly an emergency procedure; enginemen like to know that they're safely leading from a good water source before they "make the hallway."

Many engine companies tip their principal line with an Akron FT-2 fog nozzle, its grip handle allowing

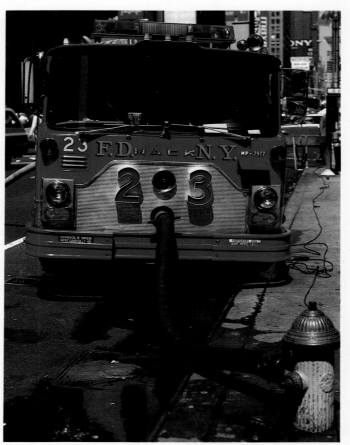

Manhattan's 23 Engine hooked up via hard suction to a hydrant.

ping you on the shoulder — 'Kev, you need a blow? You want a break, pal?' But you hate to give it up. For my money, it's what firefighting is all about," says 58 Engine's Kevin Munnelly.

While getting water on the fire is the first priority of the engine crew, the firefighters of truck companies give their attention to ventilating the building. (Once and for all: *engines* are the rigs that pump water and carry hose; *trucks* have the ladders, forcible-entry tools and other heavy equipment.) Bystanders readily understand the efforts of the firemen with the hoses, but they are often bewildered, and even angered, by the doings of the truckmen, who set about smashing down doors, breaking windows and cutting gaping holes in roofs with power saws. Probably the single most-asked question about

them to vary the throw from narrow to extremely wide. The wide spray is ideal for protecting the engine crew as they advance behind it into a superheated atmosphere. Other units prefer the old-fashioned ¹⁵/₁₆-inch brass tip, which blasts out a solid stream with more water but less protection than the fog nozzle. All engines carry both. Whatever the appliance, "the nob" is the point of the firefighting sword, and enginemen compete cheerfully but ceaselessly to control the line. "Some clown is always tap-

firefighting is: Do you guys really have to do all that damage to the building, just to put out some little fire in a downstairs room?

The answer is yes. Truckmen don't perform this dance for their own amusement. Venting allows poisonous smoke and heat to rise out of the building, improving visibility and lowering temperatures so that firefighters inside the structure can attack the fire more effectively at its source. It also facilitates the other job of the truck companies: searching

the building for possible victims or people who might need help evacuating. In an occupied structure fire, it is common policy for first-arriving units to conduct a primary search of all floors, followed shortly thereafter by a secondary search carried out by completely different teams. Every firefighting team works out its search procedures in considerable detail, tailoring its efforts to the floor plans most often encountered. With zero visibility and near-unbearable heat, it's necessary to split up and hit every single room quickly with a preplanned search pattern.

One of the greatest dangers faced by firefighters is the backdraft, or oxygen explosion. In an unvented structure, heat and gases can build dangerously while the fire itself slowly suffocates. Left alone, a fire in a hermetically sealed building would die from lack of air — just like the science teacher's candle in the jar. But buildings aren't hermetically sealed; some "breathe" a lot more than others. Small amounts of air will seep into every involved building, keeping the fire alive, the heat escalating and the atmosphere explosive. Suddenly, a window breaks or a door is opened, and the inrush of oxygen generates instantaneous combustion, shooting flame lethally in a dozen directions.

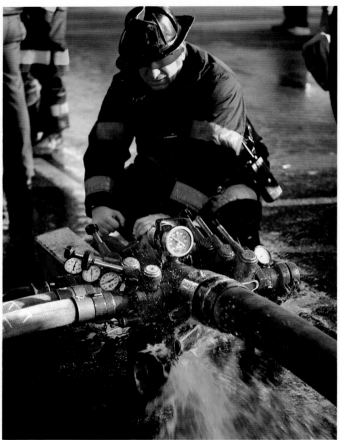

Manifold can supply six 2½-inch lines simultaneously.

"When you're advancing the line," says one old-time engine officer, "you really listen for those beautiful venting noises — glass breaking, guys knocking down doors, the Partner saws running up on the roof. When it's all quiet — no sound but you and your little hose-line — now that's not good. It sounds crazy, but you want to hear the fire crackling and roaring; that means it's getting air, it's not banking down.

"When the building's been opened up good, inside firefighting isn't so bad. You can feel the temperature drop as the heat goes out the top. Of course, heat and smoke rise, so you're usually flattened out on the floor anyway. But then you can rise up, get a bit more comfortable, and you can start to see what you're doing as the smoke lifts out. Now you can really start knocking the hell out of the fire with line."

Truckmen then move into the fire rooms with ceiling hooks and Halligan prying tools, pulling down walls and overhead panels in search of hidden pockets of fire. The man on the nob hits each sign of fire with an accurate blast from the nozzle. This overhauling work in the steamy confines of a burned-out building is dirty, exhausting and much more time-consuming than the firefight itself. The rescues, the roof work, the slow advance with the nob are terrifying but

A vacant tenement "gets going good" up in Harlem. Radio-equipped outside vent man maneuvers to pull up a 1¾-inch hose line for a water attack from his vantage point on the fire escape.

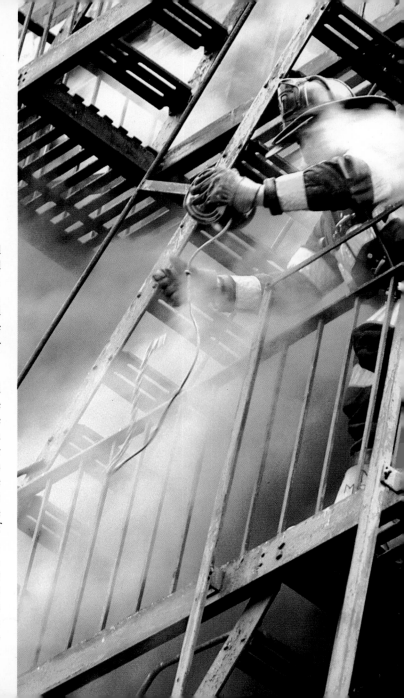

undeniably exhilarating. Overhauling is necessary to avoid rekindles, but it is pure grunt work, back-breaking and anticlimactic. It is the rare and odd firefighter who enjoys it.

FDNY firefighting is a carefully orchestrated team effort, with each company, each piece of apparatus, and indeed each man having a defined job and specific position on the fireground. Few other departments delineate these responsibilities with such precision.

While initial responses will vary with location and building type, the typical assignment on a telephone alarm is two engines, two trucks and a battalion chief. These companies are said to be "due" at the box in accordance with their distance from the fire building. Here is the S.O.P. for most New York structures: the first-due engine stops slightly past the fire building, its company heading for the fire floor with an attack hose-line while the driver/MPO remains behind to get the rig onto the nearest hydrant. The second-due engine, arriving moments later, takes charge of the floor above the fire to look for signs of fire extension. The first-due truck stops directly in front of the building, extends its powered aerial ladder to the roof, and puts two or three men onto the roof and fire escapes in case venting is required. Meanwhile, the truck's officer and his two-man team head into the building to supervise forcible entry, rescue and evacuation. The second-due truck sets up a lad-

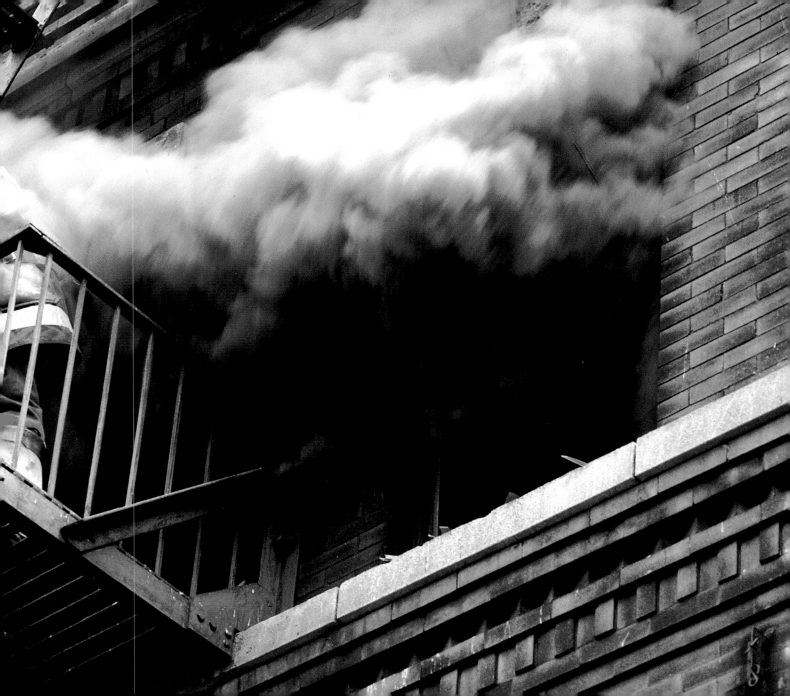

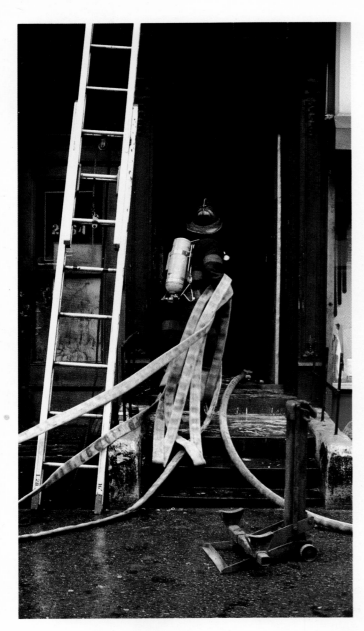

der at an adjacent building, preferably one with a roof of the same height as the fire building; its crew takes responsibility for search and rescue on the floor above the fire. The battalion chief runs the show from the curb, communicating via Handie-Talkie radio with all companies as well as with his aide, who remains with the chief's vehicle to communicate with the dispatchers.

Each company member has a choreographed position at the fire, assigned at the beginning of the work tour and drilled regularly. All FDNY engines and trucks carry a hefty complement of one officer and five men, sometimes six. In engine companies, the officer leaves the MPO at the rig and leads his nozzleman and backup to the seat of the fire with the hose-line, while two more firefighters position themselves behind in doorways or on stairs to "hump" the charged line and watch for kinks or other problems. In a fierce firefight, these positions will be rotated to share duties on the nob, the officer staying alongside to direct the stream and tune in for trouble — the possibility of flashover or collapse. Truck companies usually leave their chauffeurs to operate the aerial ladder while they separate into two teams: the officer takes his two-man forcible-entry team into the fire building (first-due truck to the fire floor, second-due a floor above, same as the two engine companies), carrying axes, Halligan tools and a small pressurized water extinguisher. The truck roof teams divide their attention between the roof, which may need to be carved up with a gas-powered Partner saw, and the fire escapes, where rescues and evacuation take place. The firefighter on the fire escape is called the outside vent man; he is a radio-equipped swing player with freedom to roam over and around the building in search of trouble spots.

Truckman of Ladder 42 backs out of an occupied four-story Bronx tenement after taking part in a secondary search of the floor. Fortunately, no one was found.

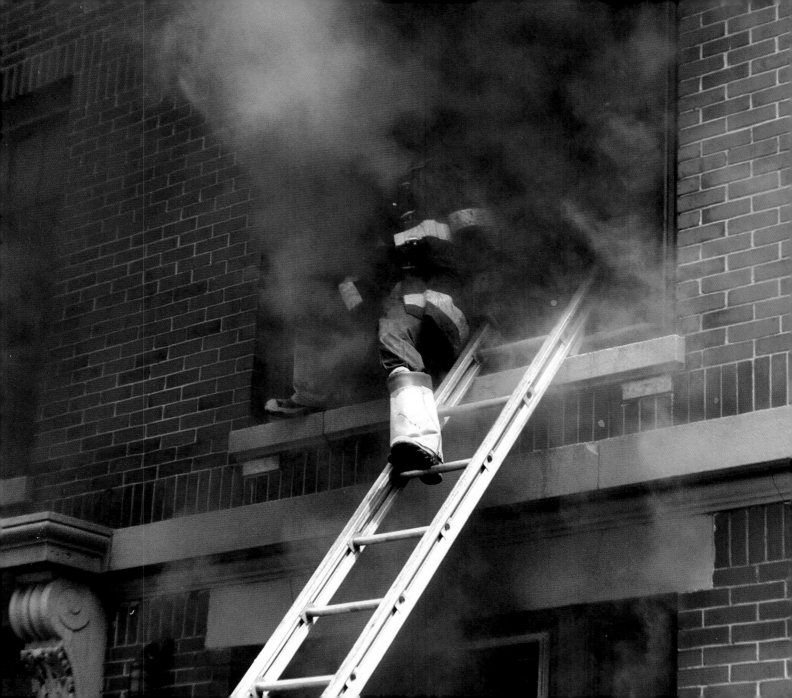

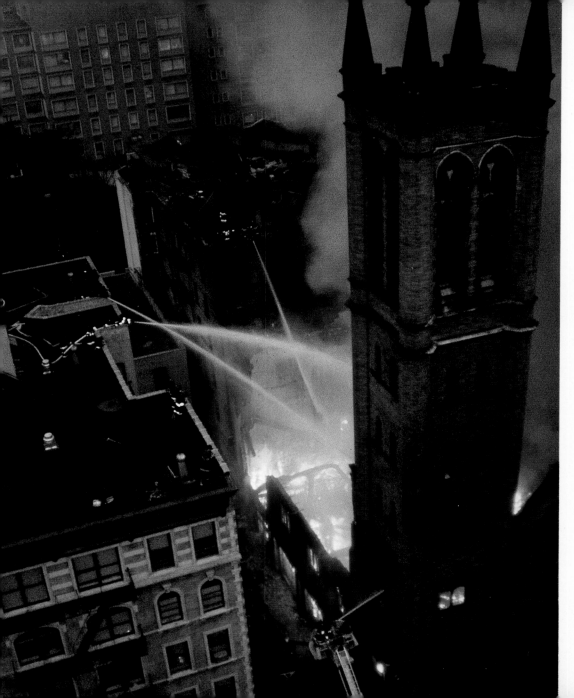

Forcible entry is the bane of the truckman's existence. New Yorkers don't merely lock their doors — they turn their apartments, offices and buildings into fortresses in a never-ending battle against burglary and assault. Steel doors are routinely triple-locked with dead bolts and impregnable floor-to-ceiling police bars. Windows are barred or fitted with child-guard gates. Truckmen often find it preferable to breach walls rather than to argue with a vault-like door in a superheated hallway.

The occasional glitch aside (vandalized hydrants, their bonnets torched off for a few cents' worth of brass, are a constant problem), this drill unfolds with disarming ease and quiet — no shouted orders, no wasted motions. Even if it appears that the alarm is a nonevent — a burning pot on the stove or rubbish in a hallway — the companies will move smoothly through most of their

All-out fifth alarm at the Grace United Methodist Church on Manhattan's Upper West Side. Units bombard the blaze from the roofs of exposure buildings.

practiced routines. Portable radios are carried by all officers, all chauffeurs in the street, roof and outside vent men, and enginemen on the nob, as well as by the chiefs and their aides. Everyone can communicate with everyone else around the fireground.

A good working fire will cause an early-arriving company to signal a "10-75" on the air — a request to fill out the first-alarm assignment with a third engine, a rescue company and another chief. A higher-ranking division chief will usually respond to take overall command. The rescuemen will help with the searching and roof work, and the extra engine will scout exposure buildings for fire extension. But these and subsequent-arriving units will report to the chief for instructions instead of assuming predetermined tasks.

If the fire continues to grow out of hand, the command chief will request additional engines and trucks. In particular, he will often call in one or more tower ladders, remarkable machines with an enclosed three-person bucket at the end of a telescoping boom instead of a conventional aerial ladder. The FDNY has honed to perfection the firefighting capabilities of these versatile rigs: they can be set up rapidly, and their crews can rescue victims from windows, ventilate peaked or unsafe roofs without setting foot on them, and sweep rows of windows with a surgically accu-

Venting the roof with axes and Partner saws at a Harlem second alarm.

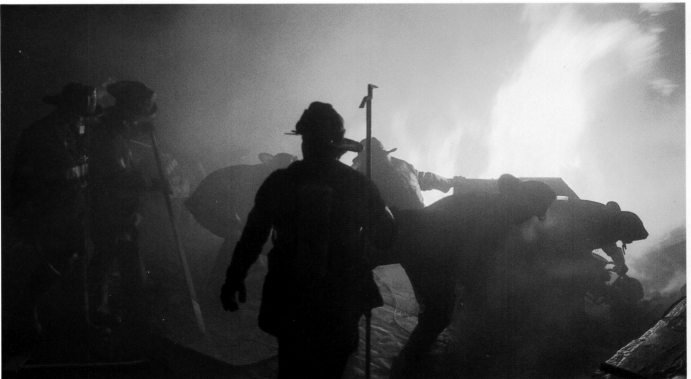

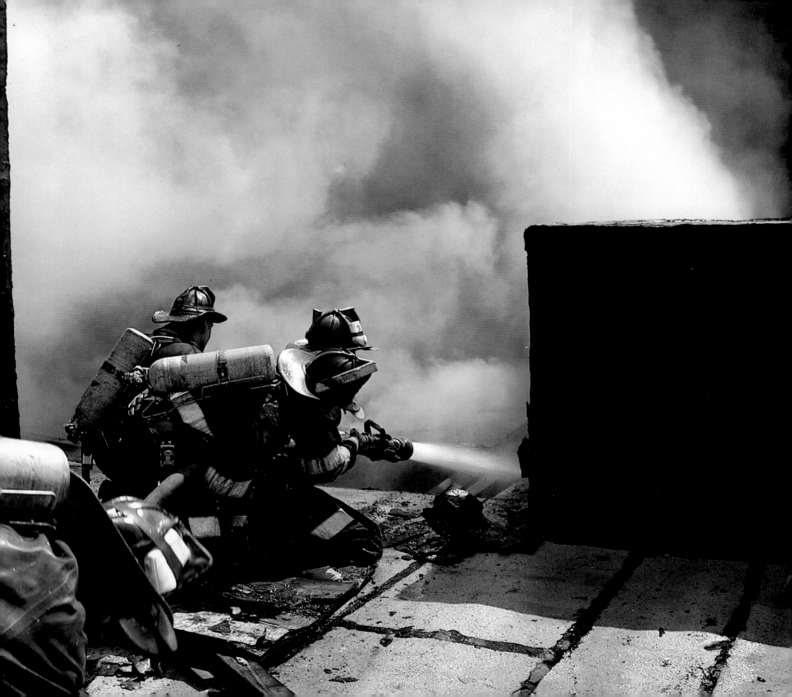

rate water stream. That stream has sufficient hydraulic power to tear apart ceilings, knock down interior walls and burst into flaming cockloft spaces. Again, portable radios allow close coordination between the tower ladder's stream and those of crews inside, so that the fire won't be driven back onto the hapless enginemen with weaker water power. It is a rare and monstrous fire that can stand up to an attack of massed FDNY tower ladders.

For that matter, it is a rare event for any New York blaze to go beyond "all hands" — the term used when the full first-alarm assignment is at work. If more manpower is required, perhaps to conduct numerous rescues or to prevent extension into exposure buildings, the chief will ask for transmission of a full second alarm. Third, fourth and fifth alarms can follow, the latter putting 40 pieces of equipment and more than 150 firefighters at the scene. Special calls will doubtless go out as well for department and city ambulances, satellite high-volume water rigs, additional rescue companies, a searchlight truck, foam units for stubborn

Messy overhauling at a fatal fourth alarm in a row of wood-frame residences, Gun Hill Road, the Bronx.

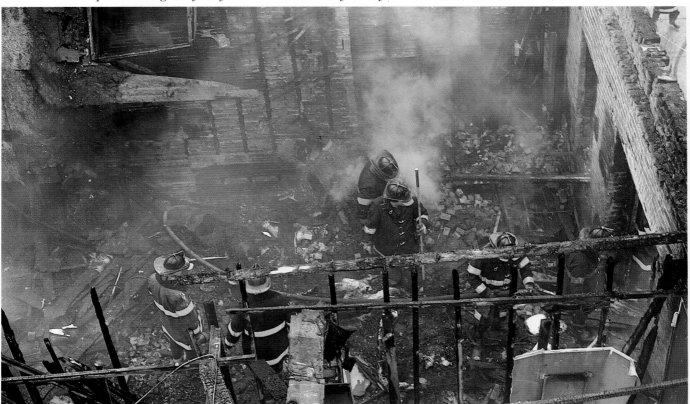

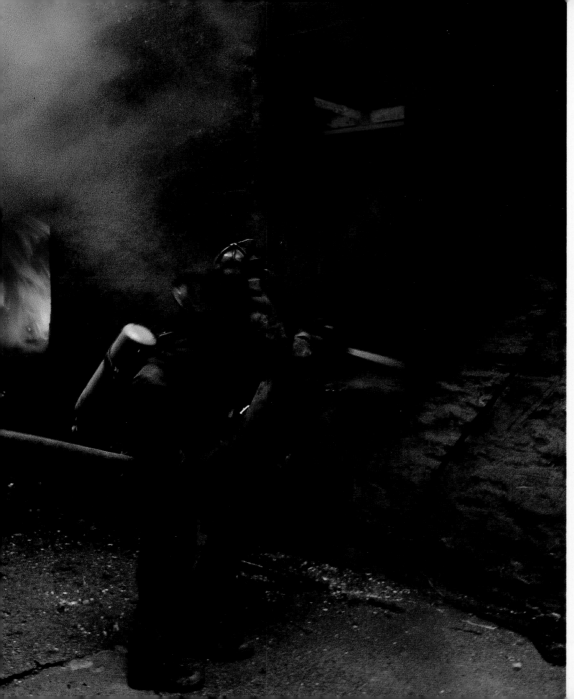

The crew of 92 Engine attacks a burning Bronx vacant from the rear.

basement blazes, even a fireboat if a heavy water attack is possible from offshore. Specialty officers — communications and safety chiefs, fire marshals, the borough commander — will also respond before the fire reaches fifth-alarm status. Usually the top department brass, the fire commissioners and even the mayor will convene at epic blazes.

The stupendous size of the New York Fire Department allows a commander to call for seemingly unlimited reinforcements, a luxury unknown to smaller cities which rely on cumbersome mutual-aid agreements. Theoretically the department could fight several fifth-alarm fires simultaneously with ample reserves remaining on duty. Veteran Chief Lewis Harris recounted a gigantic 1977 blaze in two blocks of wood-frame dwellings in

Tower ladder employs heavy stream at a fifth alarm in several Harlem tenements.

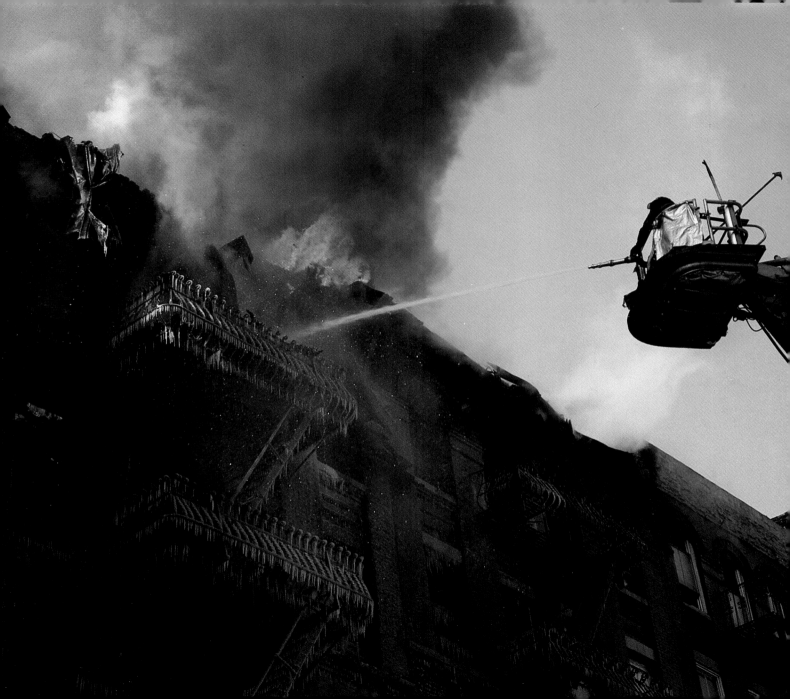

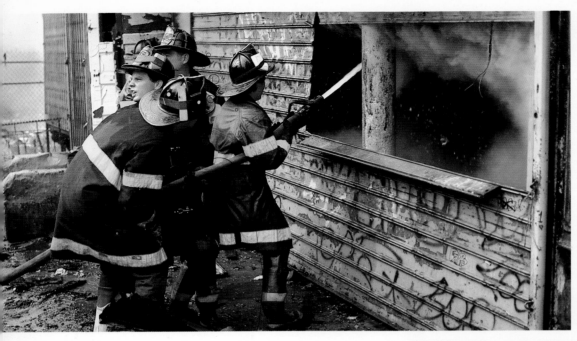

(Left) *Nozzleman operates hand-line into a storefront after the steel roll-down security gate was cut open with a saw.*

(Right) *A 500-gallon-per-minute nozzle from one of the city's two 100-foot Sutphen tower ladders is moved from window to window in order to drench the whole area inside.*

(Below) *A battalion chief gives orders to additional companies via Handie-Talkie, while peeking through a hole made by firefighters in a cinderblock wall at the entrance of a vacant building. The wall is used to keep vandals—and firefighters—from entering.*

Bushwick, Brooklyn; the department response swelled in minutes to a full fifth alarm, and the equivalent of two additional third alarms were then called to the scene! This was a "borough call" response, with units rolling from every other borough to take part in the fight (even Staten Island companies relocated to cover Brooklyn). "We could have doubled that total if we'd had to," said Harris.

Companies around the city modify their predetermined responses in accordance with the types of buildings in their district. After all, Staten Island has tract homes, Queens has older single-family houses, the Bronx has its H-shaped apartment blocks with six floors and perhaps a hundred units, Harlem has tenements, Brooklyn has everything from two-per-floor railroad flats to wood-frame "Queen Anne" victorians, and midtown Manhattan has the largest agglomeration of high-rises on the planet. Elsewhere in the city are factories, warehouses, piers, shipyards, subways

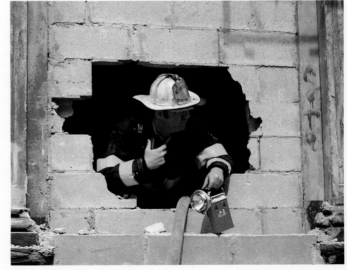

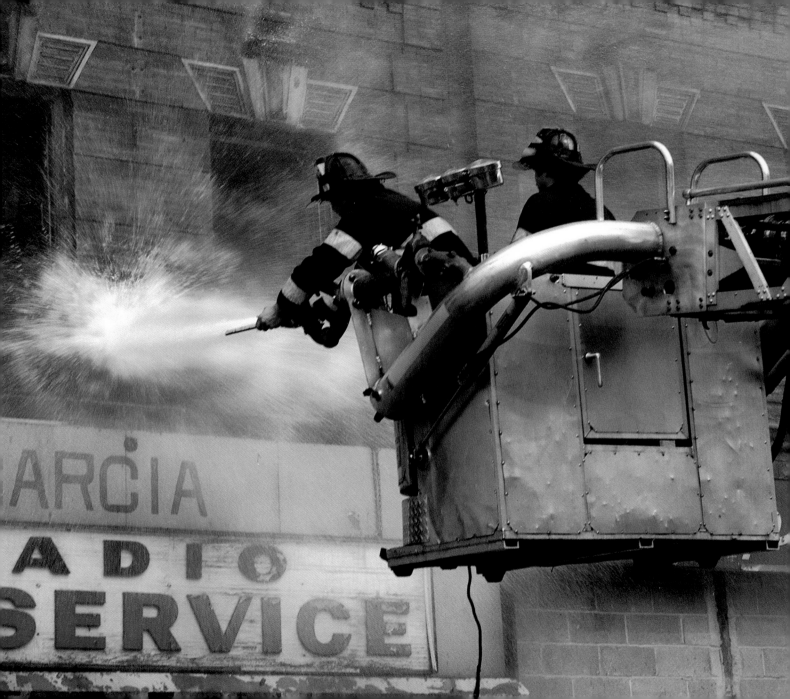

and strips of "taxpayer" commercial buildings (connected, to the firefighters' dismay, by common cockloft spaces). New York firefighters see it all. It's hard to imagine that any city in the world could have a greater variety of fire hazards. Regardless of the particular situation, the firemen respond with rehearsed and predictable moves.

Not that there isn't room for initiative. An engine crew might have to conduct rescues and forego hose work if the trucks are delayed in responding. A ladder truck rolling in on a side street might discover trapped tenants who haven't attracted the attention of the companies in front of the building, and the officer might elect to drop the jacks and throw the aerial then and there. An engineman assigned to hump the line around a staircase might hear cries down the hall and set off on a hair-singeing rescue.

In fact, a reading of the official catalog for the 1984 Medal Day observances, which describes in riveting detail the 51 heroic and val-

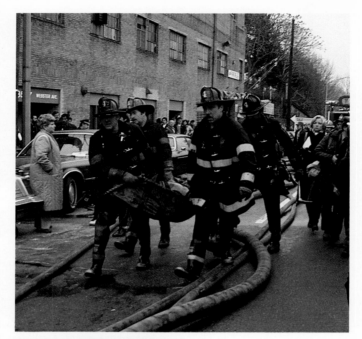

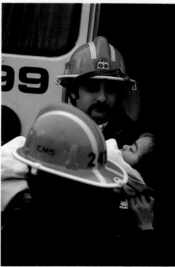

(Above) *Firefighters remove the body of a victim found in a destroyed frame dwelling on Gun Hill Road, the Bronx. (Left) Members of New York's Emergency Medical Services minister to a young victim at the same incident. The child was successfully resuscitated.*

orous acts deemed worthy of medals in the previous year, shows that initiative and improvisation, coupled with courage and determination, saved the lives of at least a hundred New Yorkers in 1983 alone. One reads in disbelief about unorthodox roof-rope rescues, searches of charged apartments without benefit of breathing apparatus, burned and exhausted firefighters forcing themselves back into the fire rooms for one more effort to find a missing child. The practiced procedure is a good starting point, a firefighting framework, but often it is not enough.

Still, these are exceptions; the standard operating procedure — the S.O.P. — almost always prevails. Says 16th Battalion Chief John McDermott, "You have a job to do, and you're all relying on each other to do your jobs. The citizens don't know it, but they're relying on you, too. It's an interlocking thing.

"Sure, sometimes you just have to go for it. It's a big help now that so many guys in the building have ra-

dios; if they're off on a goose chase or running into problems, they can let us know where they are and if they're getting into trouble.

"But the basic plan works. Engine people hit the fire with water. Truck and rescue people go after the citizens, other truckies open the joint up, arriving units get specific instructions as they report in, according to the situation. Everybody's where they're supposed to be, everybody communicates, the job gets done. These people are really, really good; they've got it down cold. When we're really clicking, it's a thing of beauty."

Massed tower ladders clobber remaining fire in a row of Harlem tenements. Tower ladder technique has evolved into high art in the FDNY; its combination of power and precision can make short work of almost any blaze.

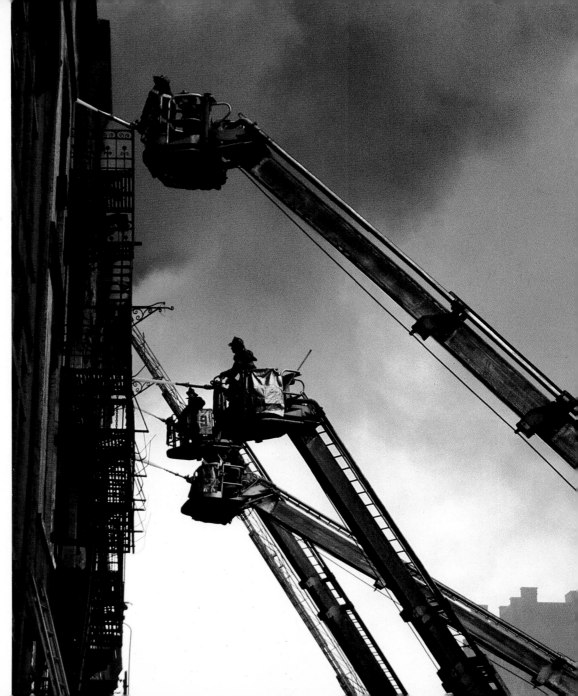

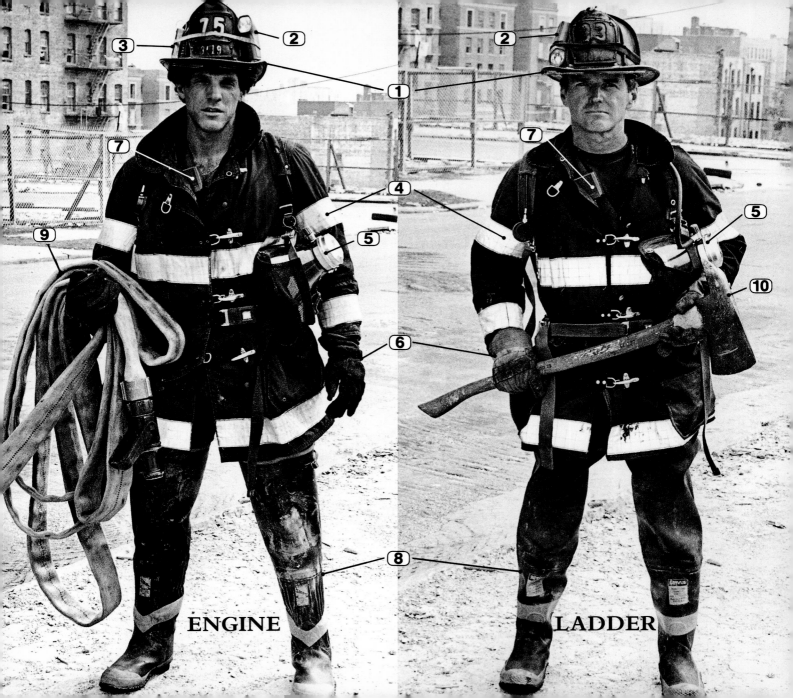

ENGINE

LADDER

Gear

Surgeons have their scalpels and and retractors, orchestra conductors their batons, and FDNY firefighters their *gear*. From plastic disposable flashlights costing mere pennies to carefully engineered, highly complex Satellite systems, the tools used by the FDNY have evolved through the years—some more than others. One area of equipment that is more resistant than others to the surge of high technology is the firefighter's personal gear: the turnouts and tools that they wear or carry. When he jumps off the first-in rigs at a 10-75, a truck- or engineman may be humping over 60 pounds of extra weight in the form of a Nomex turnout coat, a leather helmet, a Scott air pak and thigh-high rubber boots. The following pages provide a look at the personal accoutrements of the FDNY and the machines they drive.

Pictured at left:
1. Leather New Yorker helmet
2. Disposable flashlight
3. Utility knife
4. Nomex turnout coat
5. Face mask for Scott 4.5 Air Pak
6. Fire-retardant gloves
7. Motorola Handie-Talkie
8. Thigh-high rubber boots
9. 1¾-inch hose with straight-tip nozzle
10. Pick-headed axe

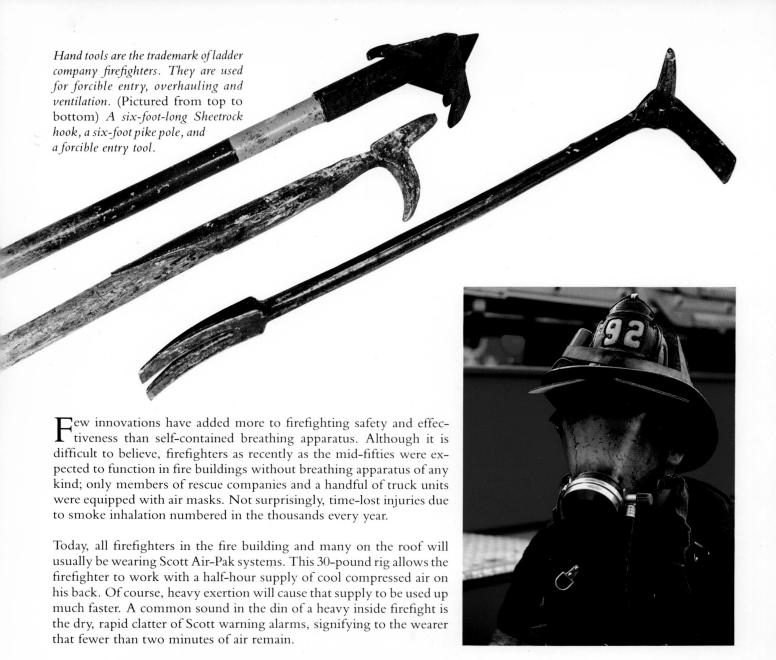

Hand tools are the trademark of ladder company firefighters. They are used for forcible entry, overhauling and ventilation. (Pictured from top to bottom) A six-foot-long Sheetrock hook, a six-foot pike pole, and a forcible entry tool.

Few innovations have added more to firefighting safety and effectiveness than self-contained breathing apparatus. Although it is difficult to believe, firefighters as recently as the mid-fifties were expected to function in fire buildings without breathing apparatus of any kind; only members of rescue companies and a handful of truck units were equipped with air masks. Not surprisingly, time-lost injuries due to smoke inhalation numbered in the thousands every year.

Today, all firefighters in the fire building and many on the roof will usually be wearing Scott Air-Pak systems. This 30-pound rig allows the firefighter to work with a half-hour supply of cool compressed air on his back. Of course, heavy exertion will cause that supply to be used up much faster. A common sound in the din of a heavy inside firefight is the dry, rapid clatter of Scott warning alarms, signifying to the wearer that fewer than two minutes of air remain.

The Cairns "New Yorker" fire helmet has been standard equipment for FDNY firefighters for more than a century. Current models are almost identical to their counterparts of Civil War vintage.

The helmets are hand-fashioned from pressed leather by a grand old family company, Cairns & Brother of Clifton, New Jersey. Thus far the FDNY has resisted the pressure to switch to more modern plastic headgear, not so much out of stubborn tradition (although that is a factor) as from the conviction that the age-old New Yorker has superior protective qualities.

Most FDNY members carry small flashlights and several wooden doorstops in an inner-tube rubber band around the helmet crown.

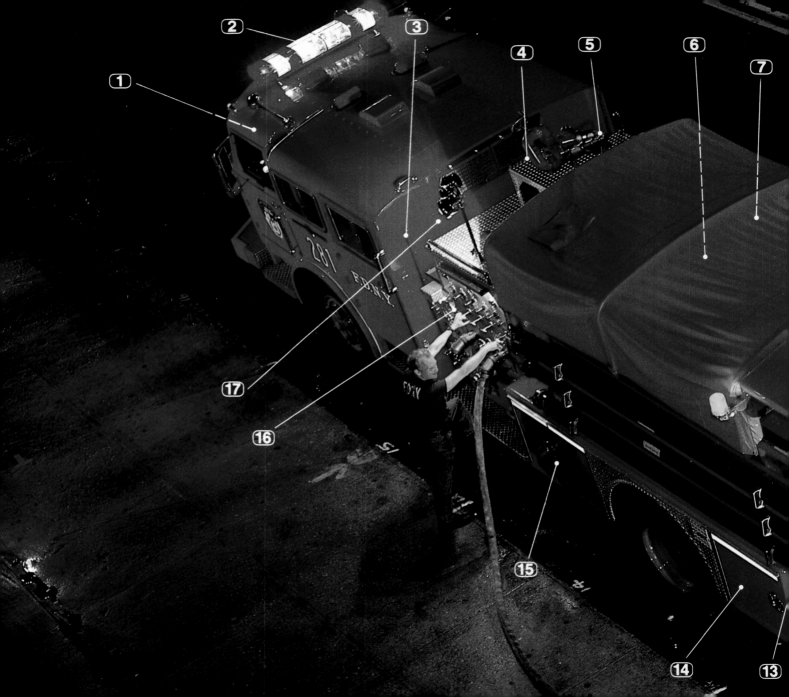

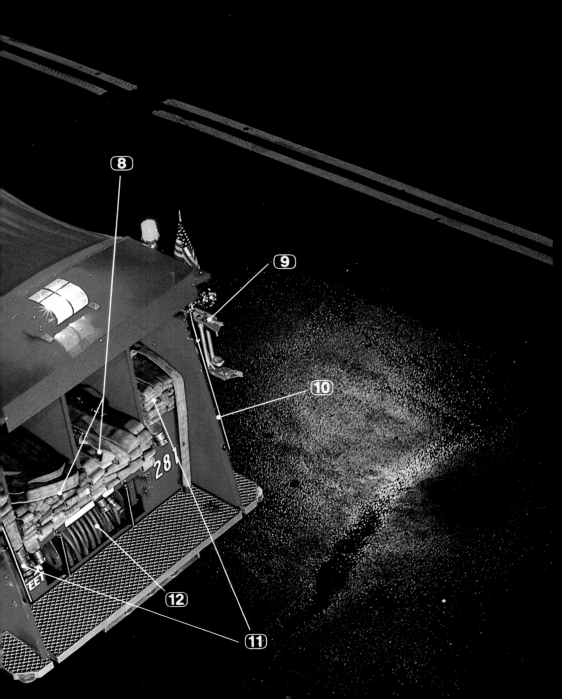

Engine

1983 American LaFrance Century Series Pumper

Empty Vehicle Weight:
 23,000 lbs.
Engine: Detroit diesel
 V-6, 350 hp.
Transmission: Allison 4-
 speed automatic.

1. 6-channel 2-way radio
2. Light bar
3. 2½″ hose
4. Akron New Yorker nozzle
5. Foam Generator
6. 500-gallon booster tank
7. Air masks and bottles
8. 2½″ hose
9. 20′ extension ladder
10. Foam cans
11. 1¾″ hose
12. Booster reel
13. Hard and soft suction
14. Chocks and tools
15. Hose fittings and valves
16. Pump panel
17. Spotlights

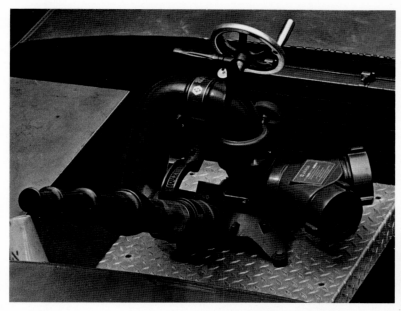

The engine company's job is simple: hook up to a hydrant, stretch a line to the seat of the fire and put "the wet stuff on the red stuff." It's tougher than it sounds: the men on the "nob" often take a terrible beating in the early stages of a firefight, and a few minutes in the claustrophobic heat of the fire room can seem like forever.

(Left) *Akron Ground Hugger deck gun can be set up quickly to deliver a heavy master stream from atop the engine, from a position in the street or from the rooftop of an exposure building. This weapon can blast out over 800 gallons per minute. Such appliances are usually brought to bear when the inside attack has failed.*

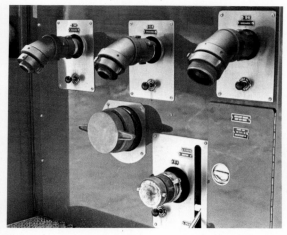

(Above) *This side of the pump has three discharges equipped with adaptors for different-size hoses, a steamer connection for use when connecting to a hydrant, and a suction inlet.*

(Left) *Engine 75 has painted large numbers on the cab of their new pumper to identify their rig for rival companies. A new light to attract other drivers' attention has also been added on the new engines.*

If a fire succeeds in overwhelming the inside attack, enginemen will regroup and proceed with evolutions for heavy water attack. Aerial ladder pipes and tower ladder nozzles must be supplied by the engines; they have no water-pumping capacity of their own. In addition, the engine's own 2½-inch lines, high-output nozzles and portable deck gun can be deployed as high-volume master streams.

But these are options of last resort; to most enginemen, standing around in the street operating heavy streams is boring and anticlimactic. To them, the focus of the job is the tough but steady movement of the nob down that hot, smoky hallway. So what if the truckies make the rescues and get the medals?

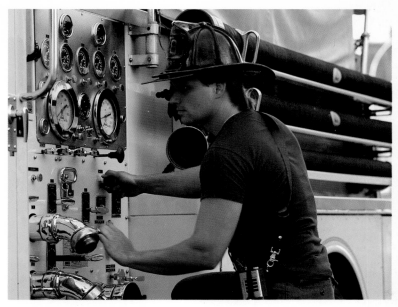

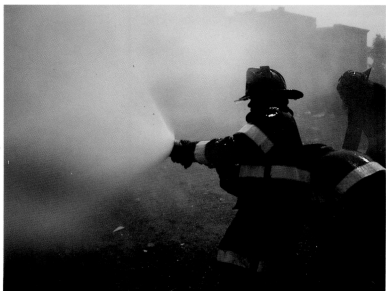

Members of 58 Engine drill with the Akron FT-2 fog nozzle, which puts out a wide protective stream behind which the crew can advance in relative comfort. Many companies prefer to tip their lines with an old-fashioned ¹⁵/₁₆-inch brass nozzle, which throws a solid stream with much greater hydraulic force but with less protection from heat and flame.

Aerial Ladder

1983 Seagrave 100-Foot Rear-Mount Aerial Ladder Truck

Empty Vehicle Weight: 32,400 lbs.
Engine: Detroit diesel V-6, 350 hp.
Transmission: Allison 4-speed automatic.

1. Ladder complement (1 each): 8' "A"; 14' scaling; 12' extension; 20' extension; 25' extension; 35' extension; 16' straight; 20' straight
2. 100' powered aerial ladder
3. Cleaning tools, Ladder pipe hose, Battering ram
4. Chocks and body bag
5. Ladder pipe
6. Spotlights
7. 2 Partner saws
8. Air masks and spare bottles
9. Spare tools
10. First-aid kit, Ropes
11. Light bar
12. 6-channel 2-way radio
13. Miscellaneous tools
14. Cutting tools
15. Chain saw
16. Ceiling hooks
17. Fans
18. Generator
19. Outrigger jack
20. Ropes and electrical cables

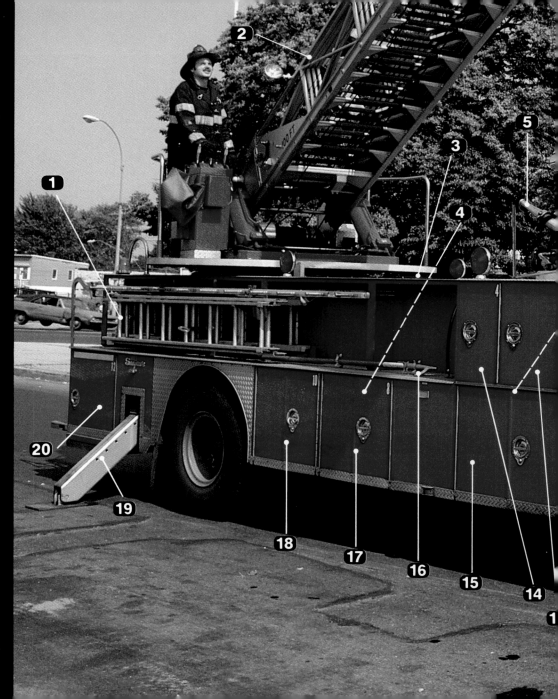

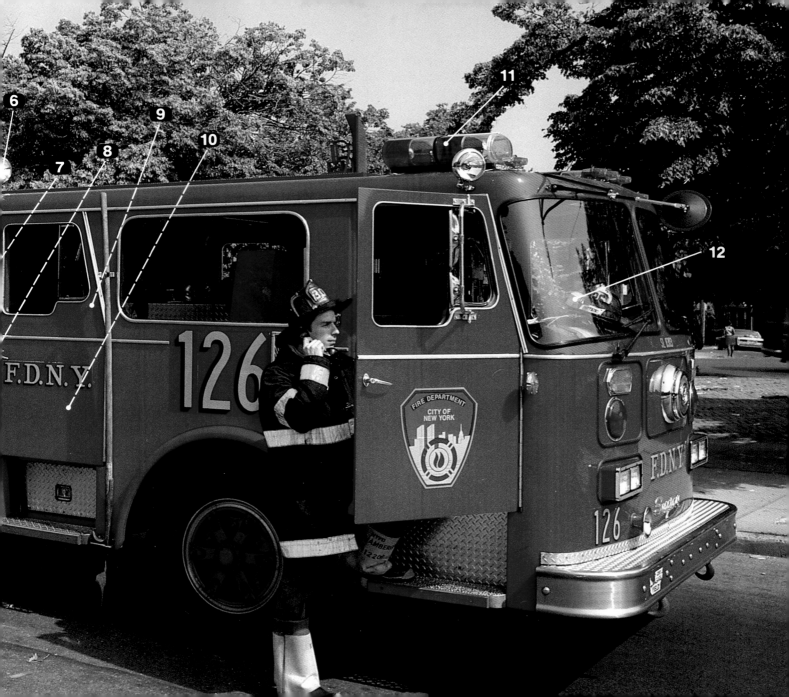

Engine crews work with water, knowing that the trucks are setting up right behind them. Truckmen take responsibility for laddering the fire building, usually with their 100-foot hydraulically powered aerials. They then give their attention to searching the building for possible victims and opening up windows, doors and the roof to ventilate the structure. When the blaze has been extinguished, truckmen move into the fire rooms with ceiling hooks, axes and prying

(Left) Lifesaving roof rope is carried by key truckmen in case avenues of escape are cut off. The backpack contains 150 feet of nylon rope that can, in a desperate pinch, be used to lower two trapped firefighters from a 10-story height. Fortunately, it is rarely used.

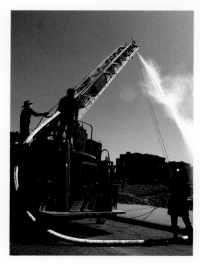

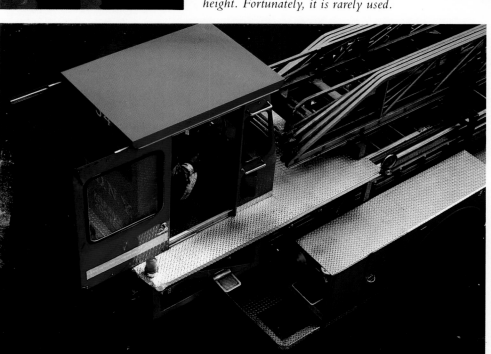

(Above) Aerial ladders can set up remote-controlled ladder pipes to direct heavy water streams into upper floors. The nozzle is safely operated from the ground via rope lanyards. With the advent of the tower ladder and its preconnected heavy nozzle, ladder pipe evolutions have become a rarity in the FDNY.

(Left) Semitrailer ladder trucks with steerable rear axles are still employed in New York, particularly in neighborhoods where narrow streets and double-parking are the norm. The man handling the rear steering wheel is known as the tillerman; it's a job requiring skill and concentration. Tillered aerials are slowly on the way out in the FDNY, as they seem to account for a distressing share of vehicle accidents.

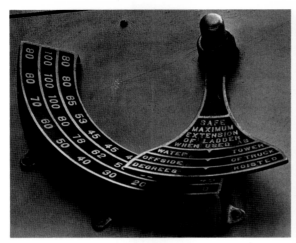

(Above) *This gauge on the 100-foot aerial ladder cautions the operator against excessive extension of the "stick" at lower angles. Torque damage and tipping can result.*

tools to seek out lingering hot spots in walls and ceilings.

Firefighters argue endlessly about which job—engine vs. truck—is harder, more demanding, more important. Truckies say venting and saving civilian lives is more crucial than fire suppression per se. The engine boys hold that direct assault on the seat of the fire is critical. Of course, both are right: firefighting is a team effort requiring both elements.

(Right) *Trucks and rescue companies carry two or three Partner power saws for forcible entry and ventilating. The saws can be fitted with a selection of special blades: carbide-tip for wood or roof cuts, aluminum oxide for slicing through metal or silicone carbide for cutting masonry.*

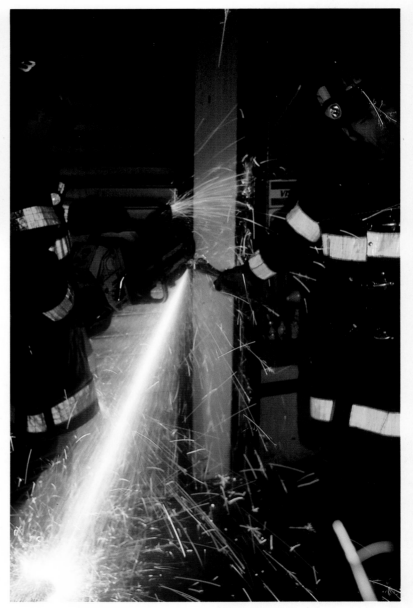

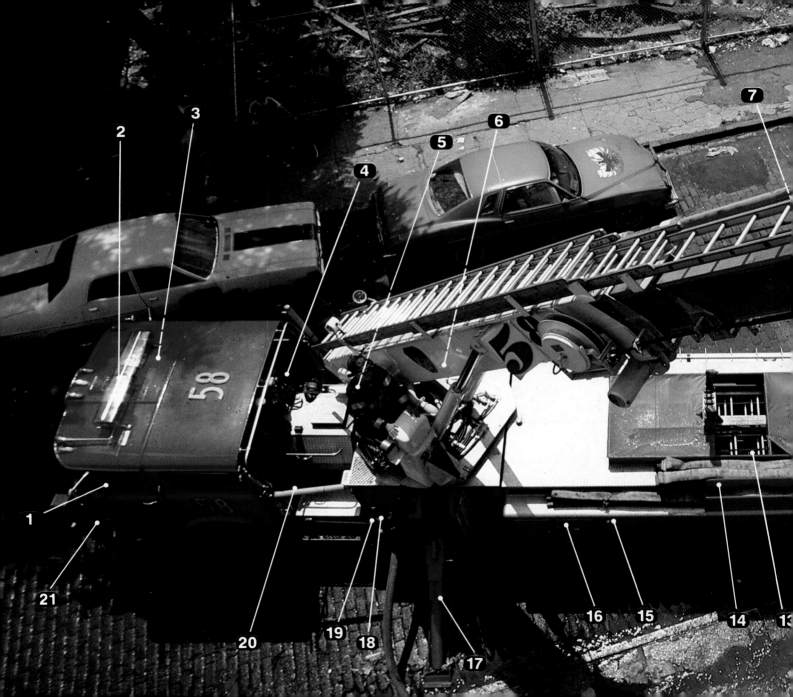

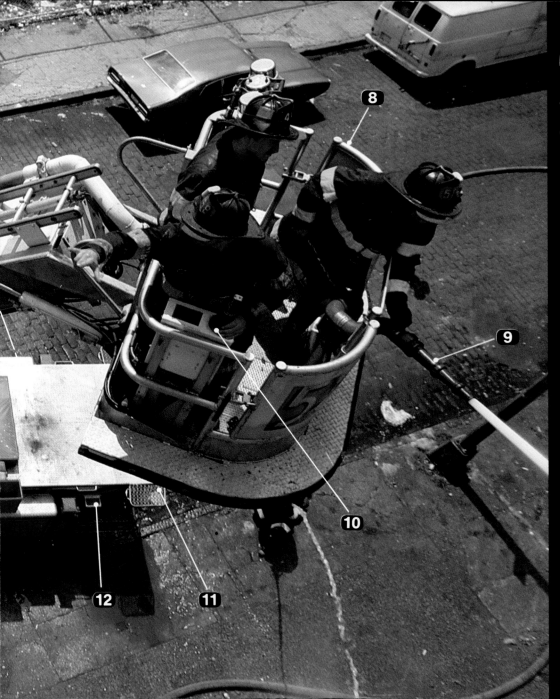

Tower Ladder

1983 Mack 75-Foot Aerialscope Tower Ladder Truck

Empty Vehicle Weight: 45,600 lbs.
Engine: Mack Thermodyne
 diesel, 6-cylinder, 275 hp.
Transmission: Allison 4-speed
 automatic

1. 6-channel 2-way radio
2. Light bar
3. Elevator tools
4. Spotlights
5. Pressurized water & foam cans
6. Air masks
7. Foam (5-gallon cans)
8. 3-man bucket
9. Akron New Yorker nozzle
10. Bucket remote control position
11. Stokes litter
12. Resuscitator and body bag
13. Ladder complement (1 each):
 25′ extension; 35′ extension;
 14′ straight; 20′ straight
14. 3½″ hose for Stang nozzle
15. 2 Partner saws
16. Master control panel for boom
17. Tormentor jack
18. Forcible entry tools
19. Water intake manifold
20. Crew guard bar
21. Outrigger jack

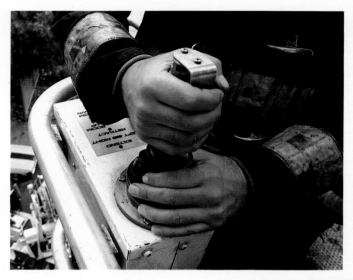

FDNY tower ladders, the first of them coming on line in 1965, have truly revolutionized firefighting in the Big Apple. Many New York firefighters have commented on their yeoman service during the epidemic of arson in the seventies; this modern "bucket brigade" clearly kept the lid on what could have been an even greater orgy of fire.

Approximately half of all FDNY trucks are tower ladders rather than powered aerials. Their bag of tricks is almost endless: window and roof rescues that spare the panicky civilian the necessity of a long climb down a slippery ladder; accurate placement of heavy water streams into rows of windows and cocklofts; roof and fire escape work without the danger of standing on weakening surfaces. Most New York firefighters mention the tower ladder in the same breath as the portable radio and the air mask when asked what inventions have made their job safer and easier.

(Above) *The joystick in the tower ladder bucket controls all rotation, elevation and extension movements. The truck chauffeur simultaneously mans the master control station at the bottom of the boom.*

(Right) *Tower ladder crews are still old-fashioned truckmen; here they join rescue company members in widening a roof trench to act as a firebreak at a greater alarm in a Bronx "H."*

(Right) *Classic tower ladder technique: truck company members put their heavy stream to work in the otherwise-inaccessible "throat" of an "H" apartment.*

(Below) *Truckmen of Upper Manhattan's 45 Truck open windows from the relative safety of the bucket.*

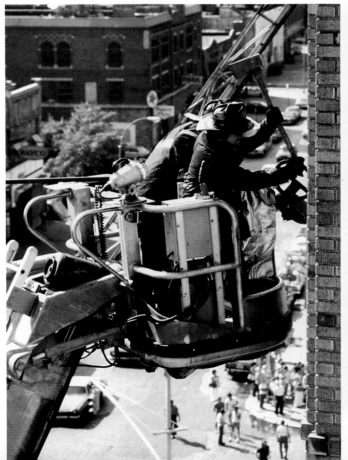

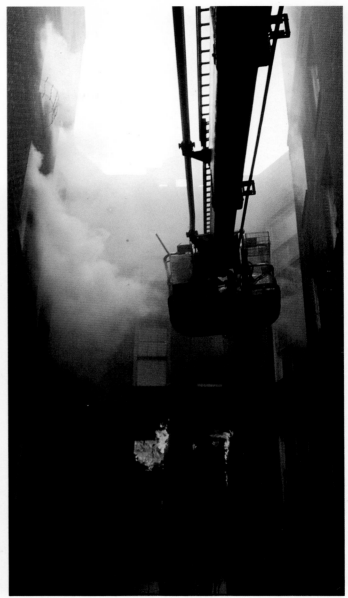

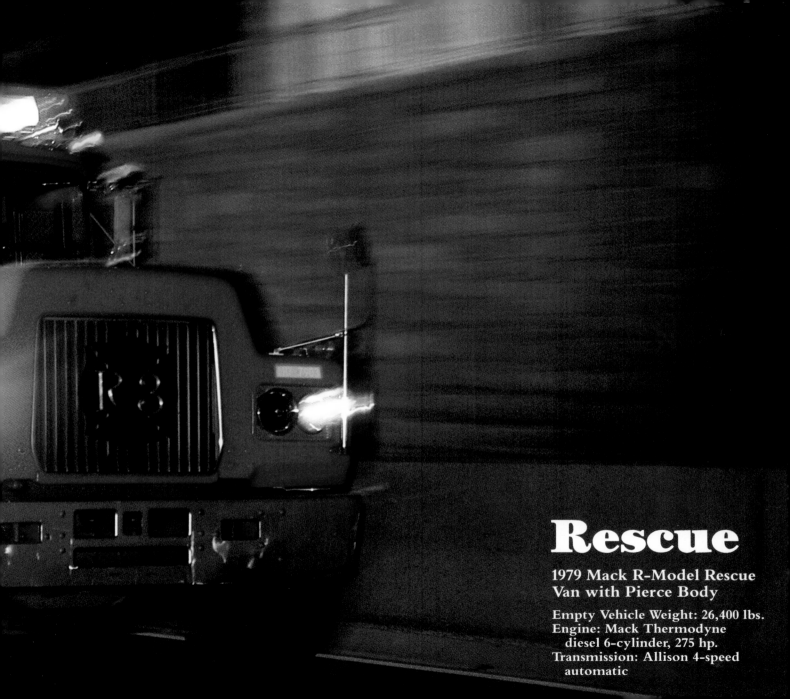

Rescue

1979 Mack R-Model Rescue Van with Pierce Body

Empty Vehicle Weight: 26,400 lbs.
Engine: Mack Thermodyne
 diesel 6-cylinder, 275 hp.
Transmission: Allison 4-speed
 automatic

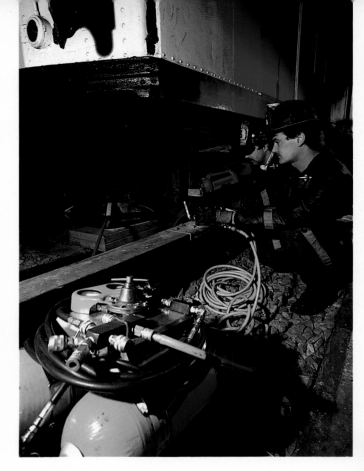

New York's five rescue companies are specialized units, equally adept at fighting fires and engineering complex rescues. The units are assigned on some box alarms, but it is more normal for them to respond on 10-75s or on a special-call basis. Their usual jobs at fire scenes are similar to those of the trucks: searches and vent work.

In addition, the rescues are equipped to handle extrications at auto or train accidents, high-altitude saves involving rappelling techniques, and other unique situations presented regularly to the fire department. Rescues 1 and 2 maintain special expertise in scuba work and water rescue; the other companies also handle hazardous materials cleanup.

The rescue companies are elite units, the only line outfits in the FDNY which are allowed to decide their own membership. A trial period on a rescue company will be followed

(Left) *The amazing Maxi-Force Lifting Bags, made of rubberized and metal-reinforced fabric, are carried by all FDNY rescue companies. Dead weights of over 73 tons can be lifted some 20 inches, and several bags can be stacked to achieve even higher lifts. The bags can be deployed quickly, and they do their jobs powered only by the compressed air in standard Scott bottles.*

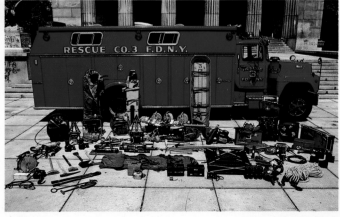

(Right) *The list of equipment carried by the rescues fills three typed pages. It includes: tow chains, electrical generator with extension cables, pavement breaker with bits, resuscitator with spare oxygen, cargo slings and hoists, ropes in several lengths, one-hour cylinders for Scott air masks, sound-powered wire telephone systems for use in subway emergencies, three Partner saws plus a chain saw, chair stretcher, Stokes litter, Hurst "Jaws of Life" tools in two sizes with compressor and attachments, smaller Porta-Power spreaders, asbestos blankets, acetylene cutting set, Halligan tools and hooks, explosimeters with probes for detecting different substances, inflatable raft and life vests, body bags, etc., etc.*

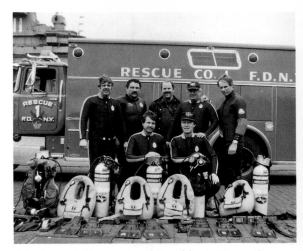

Manhattan's Rescue 1 and Brooklyn's Rescue 2 carry the added responsibility of SCUBA (self-contained underwater breathing apparatus) operations in the waters surrounding New York. They employ state-of-the-art diving equipment in addition to the normal rescue inventory, and most members are duly certified as divers.

by an interview with the captain; he will then decide, after consultation with his officers and other members, whether to give the new man the nod. It's a cherished spot for firefighters who want varied action and lots of it.

The spectacular Hurst tool, produced in several sizes and also known as the "Jaws of Life," is capable of cutting or spreading almost anything with up to 18,000 pounds of hydraulic pressure. Its colossal power is supplied by a companion gasoline generator. The jumbo-sized spreader, pictured, is normally supported by company members holding a broomstick-sized dowel beneath. The Hurst tools have saved many lives in New York, most of them gravely injured motorists trapped in crushed cars. They're a must in the FDNY arsenal.

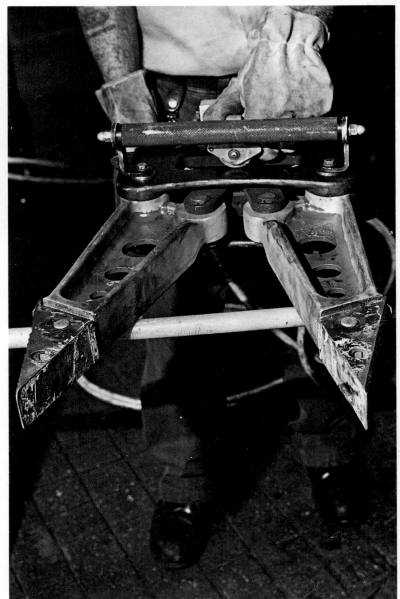

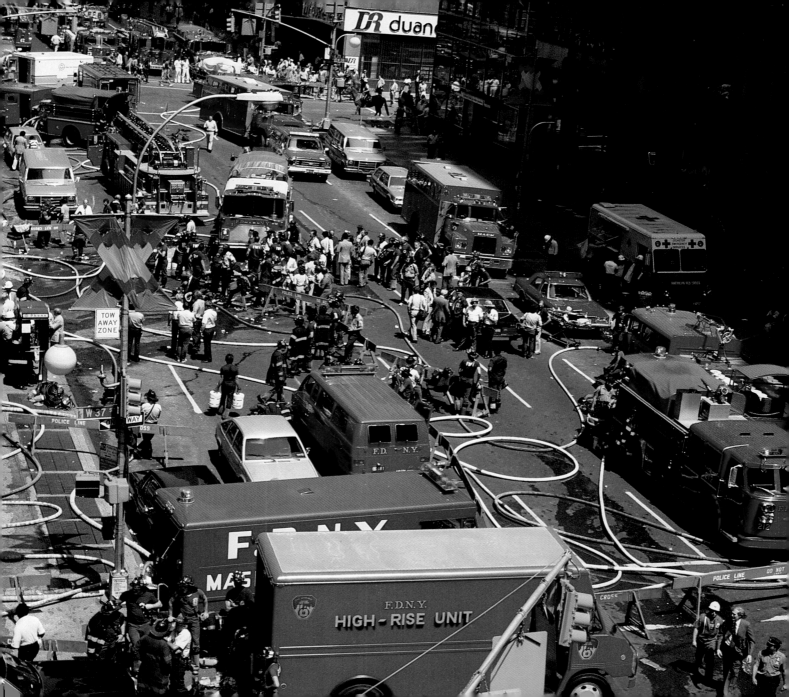

Special Call

It takes a hell of a fire to get past an all-hands first-alarm assignment. A chief at the scene might put in a request for a second alarm, yielding another four engines and one or two trucks. Or he may "special call" units to the scene.

The most common special calls are for tower ladders, with companion engines to supply their Stang nozzles with water. If there is concern about people being trapped in the building, another rescue company might be summoned. And higher-ranking chiefs will, in effect, special call themselves to the box if reports indicate a serious situation.

In addition, the FDNY maintains an inventory of unique specialty apparatus to handle any imaginable contingency. Some of these units are actually due on certain first alarms—the High-Rise Unit to 10-76 incidents, or one of the fireboats to a waterfront box. Other units roll on second or third alarms—the Maxi-Water satellites, the Field Communications van and the always-welcome Red Cross can-teen. Still others appear so seldom that even the most inveterate buffs are surprised to learn of their existence.

Here, then, is a closer look at some of the New York City Fire Department's more unusual equipment.

Searchlight 1, housed with 260 Engine in Queens, can provide countless millions of candlepower for large-scale night operations.

Special-call units clog 7th Avenue in Manhattan along with first-through fourth-alarm companies. Firefighters are battling a stubborn blaze in a Con Ed transformer below street level.

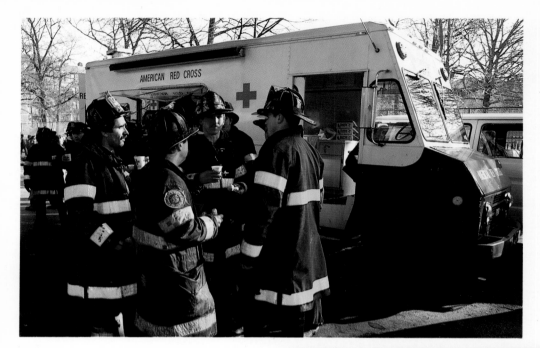

Mobile canteens, funded by the Red Cross and manned by members of the Third Alarm Association, respond to large fires with welcome cargoes of coffee, doughnuts and other snacks.

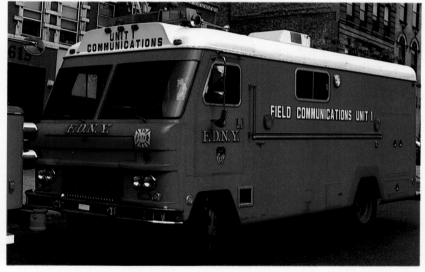

The Field Communictions Unit rolls from its Brooklyn base on most second alarms. Aboard are an officer and a firefighter; they take over signaling responsibilities at the fire scene, with the officer setting up shop in front of the building and the firefighter remaining in the vehicle to maintain contact with the Communications Office.

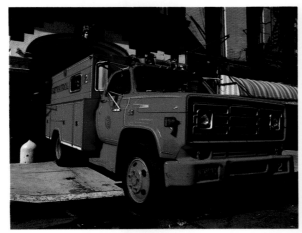

The fire patrol has three units located throughout the city. Paid by and under the direction of the insurance companies, the patrol responds to perform salvage operations at fires involving commercial occupancies. The fire patrol is the last operation of its kind in the country.

Manhattan's High-Rise Unit, normally manned in 10-76 incidents by the members of Engine 3, carries a gaggle of special gear for firefighting in tall buildings: a concrete core cutter for breaching floors, walls or ceilings; scaffolding for ceiling work, a portable manifold for refilling air bottles on the fire floor and 50 oversized one-hour Scott cylinders.

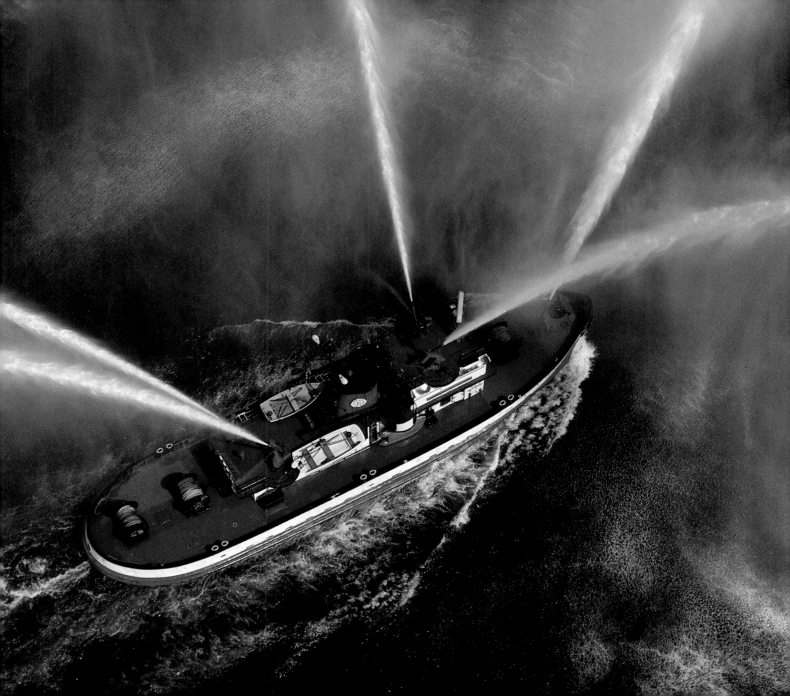

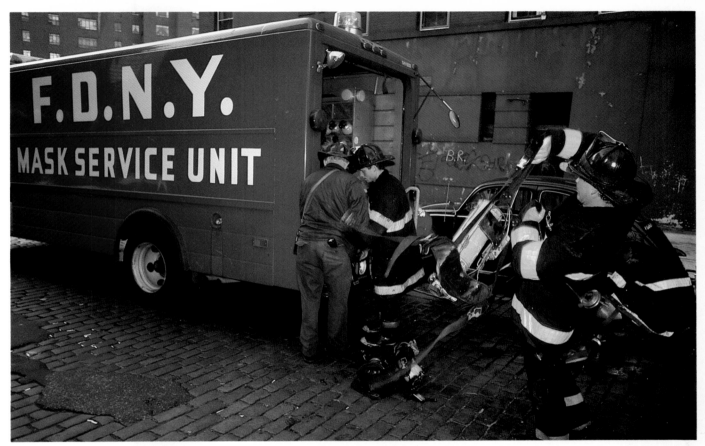

(Left) *A half-century ago, 10 fireboats protected New York's waterfront; today four remain on duty with two in reserve. This aerial view shows the 105-foot* Harry M. Archer *spewing forth a welcoming spray in the East River. The* Archer *can put out over 8,000 gallons per minute through its five deck guns, and it can also supply huge amounts of water for shore operations through its 3½-inch manifold outlets. The fireboat is named for Harry Archer, M.D., former FDNY surgeon, former commissioner, and for some 70 years the department's most tireless buff and supporter.*

(Above) *The Mask Service Unit responds from its Randall's Island base to all third alarms, 10-76 high-rise incidents, haz mat problems and on special calls to extra smoky fires. It carries hundreds of full Scott bottles and green oxygen cylinders for use in resuscitators. Although the unit can refill bottles at the scene, the more common procedure is to shuttle additional cylinders from the island to the fire scene in a second truck.*

The stupendous power of the FDNY's recently retired Super Pumper lives on in the Maxi-Water system. Composed of several interconnecting units, Maxi-Water provides high water volume and high water pressure at greater alarms and high-rise fires.

American LaFrance-Saulsbury satellite rigs are due on second alarms city-wide; they respond with companion high-volume (2000 gallons per minute) Mack pumpers. Several high-power engines can combine their outputs through a huge manifold (see page 39) to force as much as 4,700 gpm through the satellite's Intelligiant monitor. The force is awesome to behold.

(Above and opposite) *Satellite 2, its massive deck gun in full gear, operates at a fifth alarm in the Bronx.* (Following page, top) *The Maxi-Water Unit, which is housed with Engine 207 in Brooklyn.* (Bottom) *An Intelligiant gun is brought to bear on a third alarm in Manhattan.*

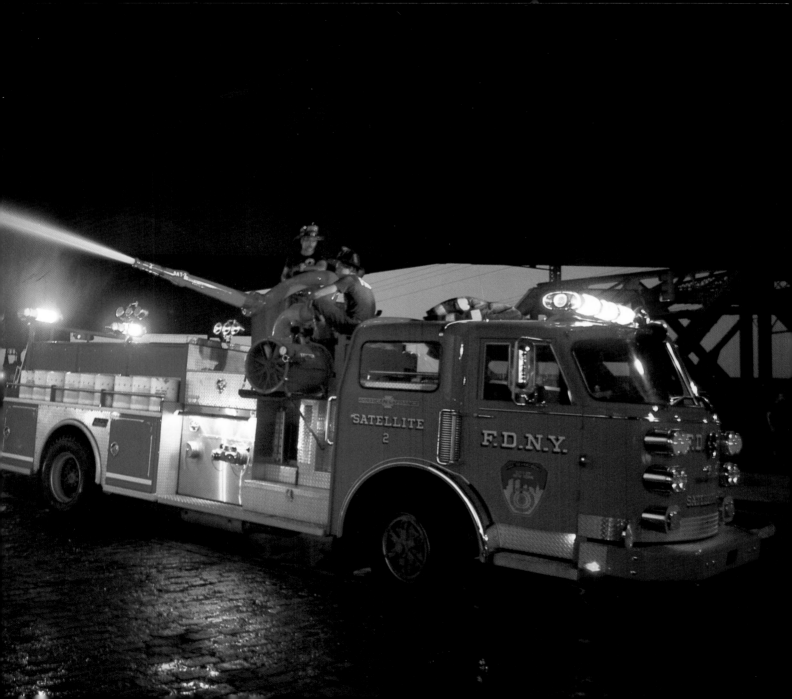

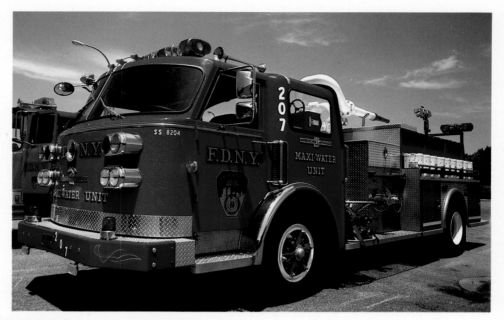

The FDNY's six satellites are an outgrowth of the hose tenders of old. They have no pumping capacity of their own. In addition to the Intelligiant and large-diameter hose, they carry portable foam generators plus liquid-protein and high-expansion foam concentrate in five-gallon cans.

In a related development, six new Manhattan engines have been fitted with third-stage pumps rated at pressures above 600 pounds per square inch—three times above the norm. These rigs are routinely due on midtown boxes, and they can also be special-called to supply internal standpipe systems in the city's tallest buildings.

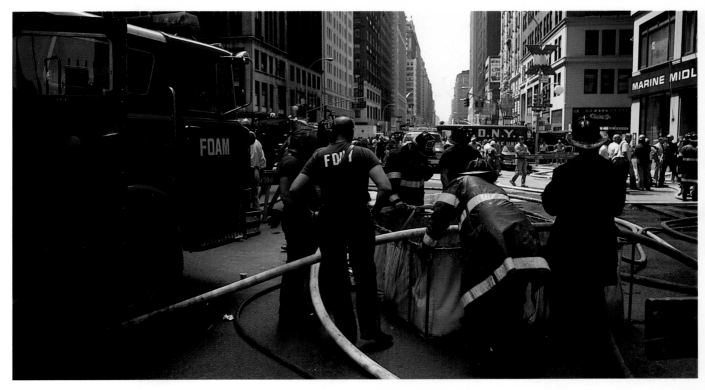

FDNY firefighters use foam to combat petroleum fires, hazardous chemical spills, and stubborn blazes in densely confined spaces—particularly basements.

Four foam units can be special called to major incidents, and individual engines and satellites can enter into foam operations on a smaller scale.

Foul-smelling protein foam, generated by the interaction of water with animal protein solids (usually ground-up fish-heads!) yields a viscous blanket of goo with tremendous heat resistance. It is at its best in fighting oil fires. The photos here show the glutinous mess in preparation. It's ugly, but it works.

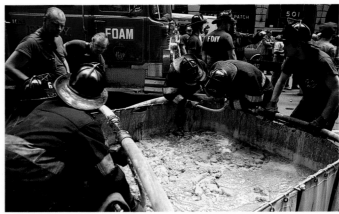

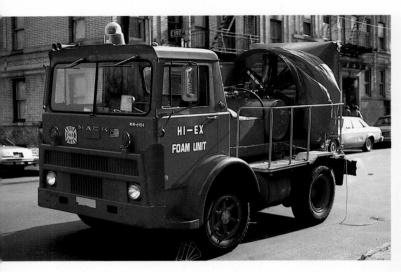

High-expansion foam is derived from agitated detergents; it looks suspiciously like soapsuds, because that's what it is. A hi-ex foam generator, mounted on a small truck, can fill an enclosed space with smothering foam at a rate of 15,000 cfm (cubic feet per minute). Hi-ex spreads fast and cools large areas with great efficiency. Foam can spare firefighters the hazardous punishment that sometimes accompanies the search for an elusive fire source.

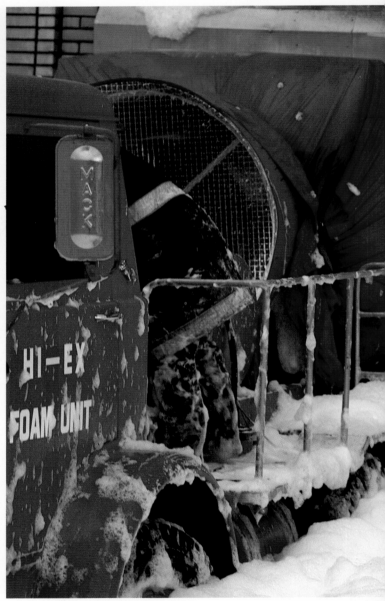

The Hi-Ex Foam Unit was called upon to fight a stubborn basement blaze when the interior of this Bronx building collapsed. There is only one such unit in New York, housed with Engine 212 in Brooklyn.

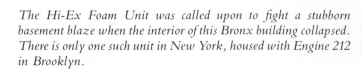

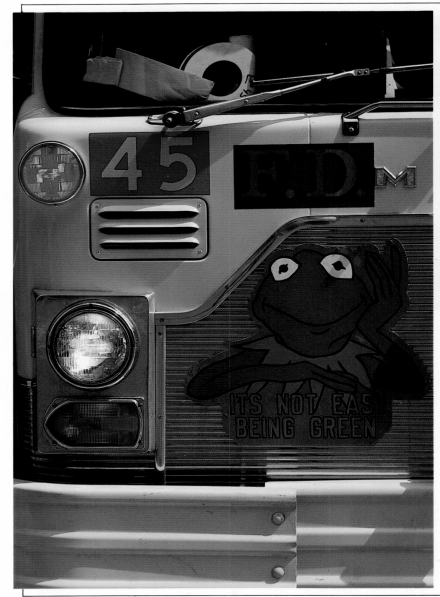

During the summer of 1981, Engine 65 in Manhattan received a new American LaFrance 1000-gpm pumper painted lime-yellow as part of an experiment to determine the value of the color in reducing apparatus accidents. An additional 10 Mack pumpers were purchased in 1981 as part of an expanded test. They were placed in service in 1982 with Engines 41, 42, 45, 46, 85 and 94 in the Bronx, Engine 236 in Brooklyn and Engines 10 and 58 in Manhattan. Nothing in recent years had stirred as much controversy as the non-traditional lime-yellow pumpers. *(Left)* Engine 45 added Kermit the Frog with his saying, "It's not easy being green," as their answer to the controversy.

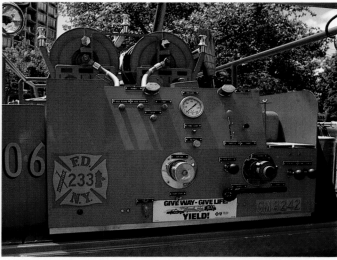

There are four brush fire units, all of which are located in Staten Island. They are equipped with four-wheel drive, a 235-gallon water tank, two booster reels and a pump that can operate as the vehicle moves. They also carry Indian pump cans, capable of holding five gallons of water, and brush brooms that are necessary in fighting brush fires in many wooded and undeveloped sections of the island. They operate with an officer and two firefighters.

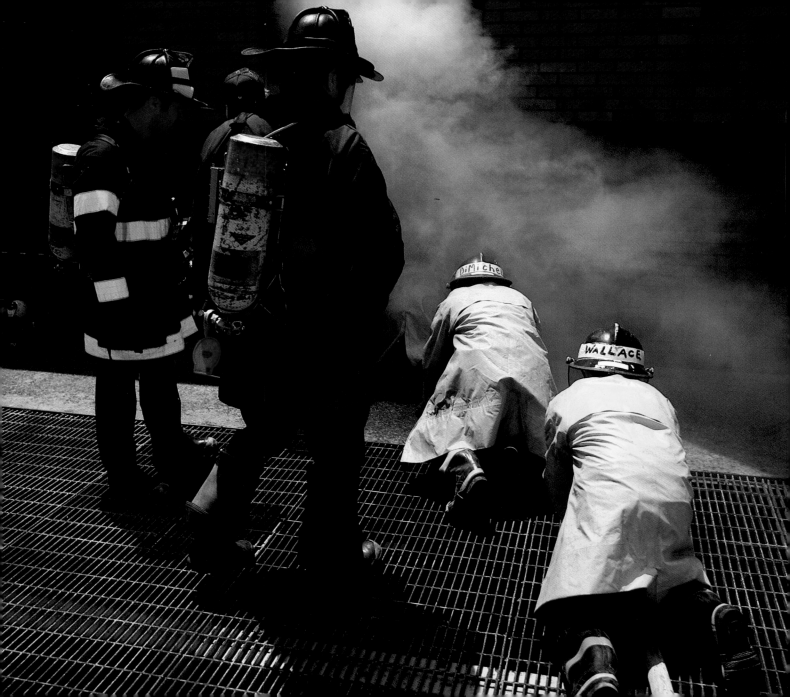

The Rock

Training and Safety

TRAINING

Gotham firefighting is not a job for everyone. One would think that the hazardous and punishing job of fighting fires, of running headlong into buildings that normal persons are fleeing, would appeal to few. But when examinations for the job were recently administered, over 40,000 men and women presented themselves for testing.

The 33,000 who successfully passed the written intelligence test were then tested for physical agility and endurance, a complex process that took six months of six-day weeks. A third of them failed.

The latest physical test was designed by Chief Tony di Martino, head of FDNY training at the huge Randall's Island facility known throughout the department as The Rock. No mere test of strength, the FDNY exam is cleverly

FDNY trainees crawl into the charged "smoke house" without masks to get a first taste of the fire room.

job-related. The applicant dons a 40-pound weighted vest, simulating a turnout coat and Scott Air-Pak, and runs against the clock to complete the following events:

1. *The Hose Drag.* Drag a folded loop of 3½-inch hose weighing 80 pounds, 75 feet out and 75 feet back.
2. *The Hose Carry.* Throw a 46-pound "short fold" of hose on your shoulder and climb three flights of stairs. Drop the hose and proceed to:
3. *The Hose Pull.* Stand in a simulated window frame and pull 50 feet of 2½-inch hose up from the ground three floors below.
4. *The Wall.* After a mandatory 100-second walk-around rest, take a run at a four-and-a-half-foot wall and vault over. Walk 75 feet to:
5. *The Ladder Raise.* Lift a 20-foot, 60-pound aluminum ladder against a wall.
6. *The Ladder Ascent/Descent.* Climb a ladder to a small platform, walk about and climb back down. The

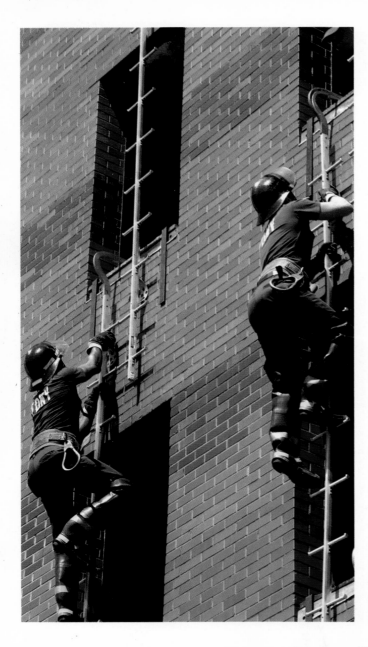

applicant gets a first taste of precarious heights. Walk 30 feet to:

7. *The Staircase Ascent With Tools.* Pick up a 15-pound dumbbell and climb those three flights of stairs again.
8. *The Forcible-Entry Simulation.* Pick up an eight-pound sledge and hit a truck tire across a long metal table. It's harder than it sounds.
9. *The Rescue Simulation.* Crawl through a U-shaped tunnel, 25 feet long and only 30 inches high.
10. *The Dummy Drag.* Lift a 145-pound dummy into a seated position and drag it across the finish line 50 feet away. The clock stops; the test is over.

A perfect score requires completion in four minutes flat plus the 100-second break. All of the events are obviously tied to the actual job; what's missing is the real rough stuff— smoke, heat, panicky citizens, zero visibility. Still, the FDNY test is a good, tough device for picking the aspirants with the right stuff.

Probationary classes at The Rock span six weeks; as many as 150 new firefighters, selected from a long civil service list, are trained at a time. The candidates study department rules, hose evolutions and the use of scores of tools carried on engines and trucks. They gain confidence by drilling several stories up with tricky pompier or scaling ladders. After learning to don the Scott tank and mask, the trainees crawl through a confidence maze in a smoke-charged room. In keeping with the quasi-military nature of the fire service, the probies learn close-order drill and the principles of military discipline, of giving and following orders un-hesitatingly. These days, relatively few candidates enter the job with military experience, and most have had little con-tact with chains of command or automatic response to officers' directives.

Scaling or pompier ladders are employed by firefighter trainees to gain confidence in dealing with heights. They are rarely used.

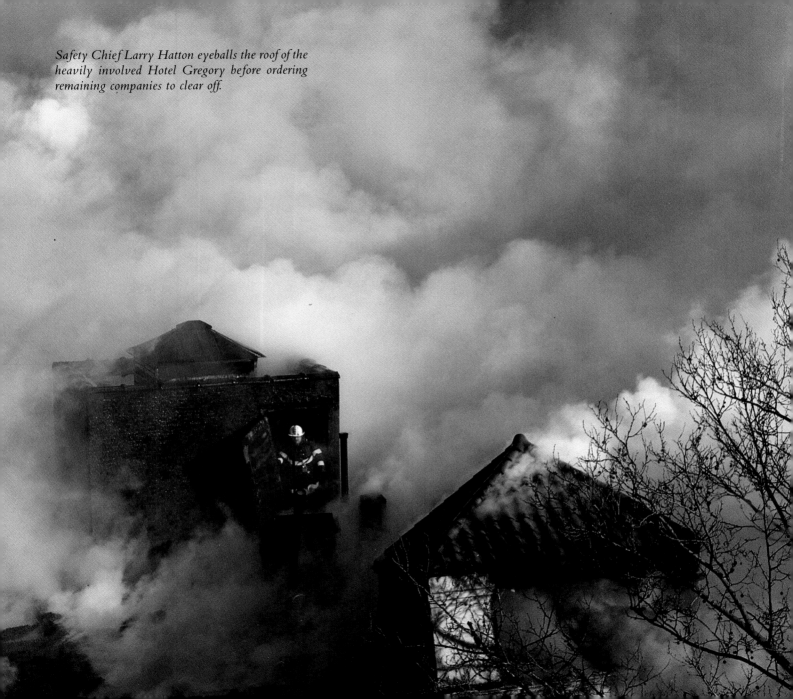

Safety Chief Larry Hatton eyeballs the roof of the heavily involved Hotel Gregory before ordering remaining companies to clear off.

As with most professions, the real learning takes place on the job. The new firefighters are assigned around the department for a year, each under the tutelage of a company officer. Most of the big guys go to the trucks, where height has always been considered an important advantage. The probies will stay alongside their officers at the fire — roof or outside vent work, for instance, will come only after a lot more experience. Individualized drills in the house will take the probies through every trick their officers know. In the houses that get the work, the probie is a well-trained veteran when his year is up.

SAFETY

There are literally hundreds of different ways to get killed or injured at a fire, with new hazards seeming to crop up every day. The chiefs of the safety battalion respond citywide from their quarters at The Rock to monitor firefighting action at big jobs. These chiefs have the power to overrule commanders at the scene if the safety of firefighters is threatened.

"In pure theory," says Safety Battalion Chief Larry Hatton, "I don't care if we lose a whole block of buildings — my job is to watch out for the well-being of the guys on the job. I'll clear a roof if I think there's a danger of collapse, or I'll order a rig moved if it's parked too close to a weakening wall." The results of this program are impressive: since reinstitution of the safety battalion in 1981, no FDNY firefighter has died in a purely fire-related trauma (although several have died from heart attacks or vehicle accidents). A decade ago, six to ten men per year were dying in collapses or flashovers while fighting New York blazes.

The safety chiefs also investigate every serious on-the-job injury, every accident involving an FDNY vehicle, and every report of chronically malfunctioning or inadequate equipment. They test and report on new vehicles, procedures, and devices that promise to improve FDNY firefighting. And increasingly, they advise other departments interested in instituting similar safety programs.

Specific disasters lead to specific safety directives. The riding list, a small printed form listing who is riding the rig and who has which job, is filled out in duplicate for each shift. A copy is left in the vehicle, and another remains at the firehouse. If people are thought to be missing and a head count is instituted, it's a simple matter to figure out who should be present and accounted for. In the horrific 23rd Street collapse of 1966, confusion reigned for hours as to who was actually missing. The enormity of the loss — 12 men — simply wasn't believable, and the worst fears of everyone weren't confirmed until dawn.

Wide truss roofs have a tendency to collapse when their beams are burned or weakened by heat. Six Brooklyn firefighters died in the failure of such a roof at the Waldbaum's supermarket fire in 1978. Today the safety chiefs will take everyone off such a roof *at once*. Indeed, few operational commanders will send troops onto a potentially dangerous truss roof in the first place.

"We're finally getting more mature and reasonable about firefighting in this town," says Hatton. "There were old chiefs in earlier days who wanted to fight every fire inside, even when life hazard was nonexistent. Today we're more comfortable with switching to an outside attack and protecting the exposures when it's obvious that *nothing* is going to save the joint.

"You still get the heroes who rant and rave when you order them out — 'Leave us in a while, Chief, we're knocking the hell out of it!' Knocking the hell out of what? We're talking now about a joint that's lost; it's history, a memory. All the people are out, or it's a vacant. What are you going to save, the wallpaper?

"Somebody has to watch these guys, particularly when they're younger. Call it gung ho, peer pressure, the macho factor or whatever you want. They'll take chances, overextend themselves. And for what? Some dump that's already had 20 fires? For the real life-threatening situation, of course, you've got to make your move, go for it. The job is always going to be dangerous. I just want to make sure we're not taking needless risks for a lost cause."

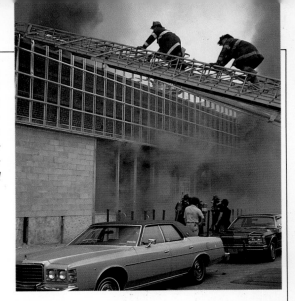

(Left) *Typical riding list for 26 Truck.* (Right and below) *A mid-morning arson blaze in a Waldbaum's supermarket led to the deaths of six Brooklyn firefighters when a truss roof collapsed.* (Right) *Only seconds from death, truckmen George Rice and Jim McManus head for the treacherous roof.* (Below) *Tools and hose-lines lie where they were dropped by the doomed firefighters.*

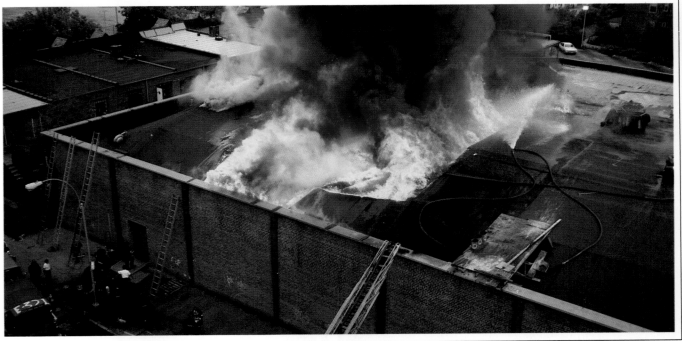

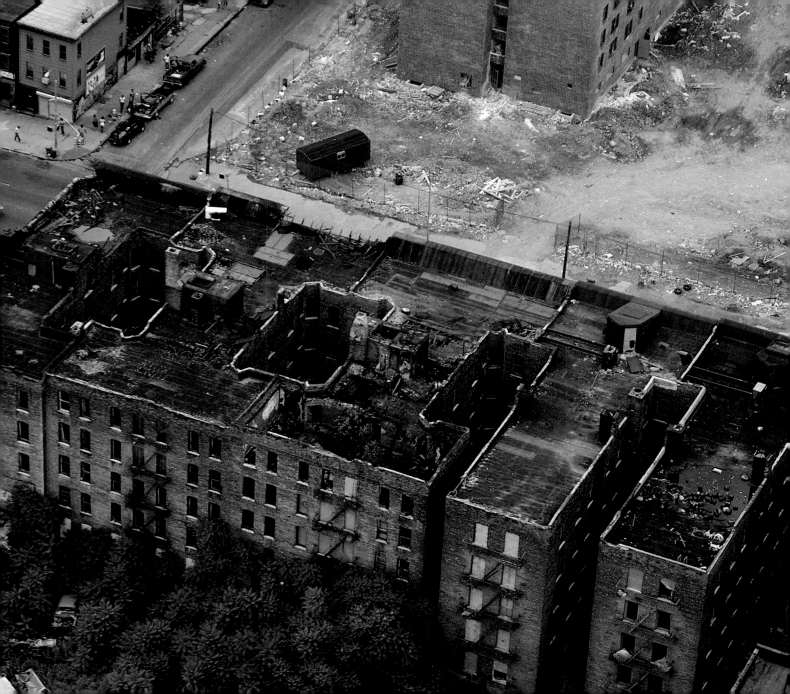

Arson

The Red Devil

On Palm Sunday, 1984, New Yorkers were shaken by a crime of savage severity. Ten women and children were executed in a Brooklyn flat by unknown gunmen, presumably as draconian punishment for some treachery in the world of Latin American drug dealing. (Police later traced the killings to an insanely jealous husband who thought his estranged wife was carrying on with the man whose family he attacked.) Newspapers labeled this massacre the worst mass killing in the city's history.

In the anguish of the moment, these same papers failed to remember an even more odious and horrifying mass killing eight years earlier. On October 24, 1976, one Jose Antonio Cordero, also enraged at his girlfriend's alleged indiscre-

An epidemic of arson in the South Bronx: burned-out "H" apartments and trash-filled lots stand as a harsh reminder.

tions with another man, struck out at her as she partied with friends at the Bronx Social Club on Morris Avenue. Cordero's rage took the form of a gasoline firebomb thrown into the stairwell leading to the second-story club. Sixty people saved themselves in a panicky exodus from upstairs windows. Twenty-five patrons were less fortunate; they died from burns or asphyxiation in the five or six minutes of explosive fire.

Strangely, arson generates little respect and awe in the hierarchy of crime. Police, insurance companies and the citizenry seem to worry about more immediate concerns. Even the crooks themselves, to the extent that they have codes of behavior, place the arsonist at the near-bottom of the criminal world, a small step above the child molester.

This disturbing nonchalance has been especially hard to understand in New York. No crime has caused as much

destruction and suffering, has done more to mar the appearance of the city, has altered the very way of urban life than has arson. One has only to look at the vast bleak tracts in the Bronx, Brooklyn and Harlem, where thousands—*thousands*—of fine buildings stand black and vacant after repeated non-accidental fires. It is difficult to find a family in these sections of New York that hasn't been directly affected by the arsonist—the groggy awakening to the smell of smoke and shouts in the hall, the terrifying flight in darkness from the burning structure, the loss of loved ones, belongings, pets, and peace of mind.

Numbers can't tell the monstrous story as well as a firsthand glimpse at what's left of the South Bronx. But they are compelling nonetheless: 135,000 reported or suspected arson fires in the decade of the seventies, resulting in 450 deaths and billions in property losses. God knows how many more

Armed Red Cap marshals about to make an arrest in a ruined vacant in the Bronx.

torch jobs went unreported or undetected. Entire neighborhoods within the city appear to have suffered aerial bombardment worse than the London Blitz.

Dennis Smith's 1972 best-seller *Report from Engine Co. 82* chronicles his adventures with the South Bronx engine company that topped the FDNY charts for runs and working fires; today 82 Engine's quarters are often jokingly referred to as "The Little House on the Prairie." Says 82's Willy Knapp, "In Dennis' day this company went out the door 9000 times in one year—what's that, 25 times a day average? Today we don't run a third that much. I guess that's one way to solve the neighborhood arson problem—keep at it until there's nothing left to burn."

Red Caps maintain high visibility at virtually all fire incidents in their district.

What caused this unprecedented orgy of fire? Says Deputy Chief Fire Marshal Matty Conlon, "You had a combination of factors impinging on the city all at once. It started off with the social unrest of the sixties—'burn, baby, burn'—and the deterioration of a lot of fine old neighborhoods as the poor moved in. A lot of landlords suddenly found they owned worthless junk. They got interested in 'selling their buildings to the insurance company,' as the saying goes."

An appalling trend of deterioration ensued. Other unscrupulous property and business owners followed suit, the more steel-nerved among them contracting for repeat fires when necessary. Arson fires in commercial taxpayer strips often vaporized whole blocks; the flames would move quickly into the common cockloft spaces and involve the establishments of the innocent.

Fire was cynically used as a prod to remove tenants from worthless properties. Landlords and torches quickly learned that a top-floor fire in the rear would work best, yielding maximum water damage, frustrating tower ladder operations and leaving the roof opened. Further fires would then erupt unbidden as junkies and derelicts inhabited the blackened, vacant structures. Building strippers, many with dismayingly adroit contracting skills, pounced like jackals, fighting over radiators, doorknobs, elevator cables.

There was an unrecognized malignant cancer killing whole New York neighborhoods. Insurance companies paid millions to criminal landlords rather than fight

the claims. The federal government's well-intentioned but idiotic Fair Access to Insurance plan kept insurance coverage available in the high-risk fire areas; not surprisingly, the fires continued. One landlord was discovered to have collected on *800* New York building fires—all through dummy ownerships. No one seemed to care; the poor moved from one ravaged area to another; firemen died in droves.

"As if that wasn't enough, get this," remembered Conlon. "If you were in a welfare apartment and you wanted to move to a bigger place or a better project or whatever, you'd wither on a list for years. Ah, but if you had a fire in your place, you'd get relocated right now, and you'd get a few thousands in cash to set up housekeeping! You're in this god-awful dump, anything would be an improvement, you're a single mother, junkies are molesting your 12-year-old daughter in the halls. Now maybe you've never done anything criminal in your life, but how long is it going to take to figure out an answer to this little dilemma? You use some gasoline on the old homestead, the fire takes out half the building, one more tenement bites the dust. There were *tens of thousands* of these fires, with the identical MO [modus operandi], and Welfare just kept making those cash payments and sticking everybody into fleabag hotels. It was unbelievable."

The arson epidemic wound down in the early eighties. The insurance companies finally started getting tough on obviously fraudulent payouts. Fire marshals got permission to interview repeat welfare-apartment fire "victims" and slow up their cash settlements. High-powered banks and developers took over thousands of ravaged acres from sleazy speculators, looking farther down the road in the manner of big-time investors everywhere. Of course, there were neighborhoods where the fires stopped only when there was finally nothing left to burn.

The fire marshals' Red Cap program has also helped to retard the various forms of arson. At the invitation of local community boards, teams of FDNY marshals, working out of a mobile-home command post, saturate a trouble-prone area of the city for several months. The Red Caps, endowed with full police powers and wearing their distinctive head-gear as their only official uniform, respond to every fire incident in their coverage area—even single-engine trash fires—to show the flag and interview possible witnesses. Firefighters agree that their work drops off noticeably within days after the Red Caps come to town. All but the most irrational arsonists will think twice about setting a fire when they *know* it will be investigated almost before the nozzle team has shut down the line.

Of course, some arsonists *are* irrational. Economic arson—for profit or insurance fraud—is just one subtype of this disgusting crime. In fact, for every arson-for-profit fire, there is another blaze that has been set as a means of assault against another human being. The twisted Cordero was thinking of love, hate and revenge—not money—when he talked three neighborhood low-lifes into fire-bombing the Bronx Social Club.

Fire and love often collide. Says Chief Fire Marshal John Regan, "You find the fire's point of origin, and it turns out to be the bed. The lady has lit it off; they went out and bought it together when love was new. Or the hooker finally gets fed up with her pimp; she squirts a jumbo can of lighter fluid all over his 30 fancy suits and lights up the closet. These crazy people are the worst—they couldn't care less about the other people in the building. I'm not defending the business guy who's torching his store, but he's more likely to try for a time when no one will get hurt. No one but the firemen, of course."

There are still other forms of arson—mindless vandalism (school fires), pyromania (psychotic arson, for the rush of power and excitement), fire-setting to get attention (common among preteens), arson to cover another crime (the incinerated office in which worthless paper has been substituted for stolen securities). The fire marshals, all former FDNY firefighters, are trained in an eight-week schooling session to reconstruct such aberrations from the ashes.

Much of their investigative work is technical—chemical

testing to see if an "accelerant" (usually gasoline) was used. Microscopic examination of glass remnants reveals whether the glass melted slowly, as it will in an accidental fire, or burst into tiny pellets, the result of a super-hot torch job.

For that matter, the investigators aren't looking *only* for arson. "I always remind new marshals," says Regan, "that they're *fire* investigators, not just arson investigators. In other words, they shouldn't make the mistake of looking only for a human cause. Fire prevention is what it's all about, after all. The Red Caps are a prevention force, a deterrent, as much as anything else.

"You have to keep your eyes open, and your mind open, for nonhuman possibilities, good old-fashioned fire hazards. A few years ago I investigated about 20 fires where it was clear that Princess telephones were somehow getting things started. We went to the phone company, and they said, 'You don't know what you're talking about, you're not electrical engineers.' I said, 'No, I'm not. But I am pretty good at finding a fire's point of origin. And I'm telling you that I'm seeing a whole lot of points of origin that have a melted Princess phone dead center.' Turned out there was a transformer inside, for the little night-light, that was overheating. You don't see a lot of Princess phones these days."

The job of fire marshal doesn't appeal to everyone. It takes patience, determination and willingness to plod through endless interviews and fire rooms. An instinct for the jugular doesn't hurt either. Many firefighters say, in so many words, "I came on the job to fight fires and save lives. If I'd wanted to be a cop, I'd have been a cop."

But there are lots of ways to fight the Red Devil. Says Harlem Red Cap and former engineman John Bassano, "I put in 12 years on the back step of the engine, and I've pulled out enough dead people to last me. That's just reacting to the arsonist, or the idiot who smokes in bed. Now I'm not just reacting—I'm after his ass."

Fire marshals and police shield arson suspect from enraged neighbors at Manhattan fire scene.

Taking it In

66 People don't believe this, but I can remember every fire I've
been to, and that's got to be over a thousand fires easy. So can
everybody on the job. Try it sometime. Get a company sitting down
together, pick some fire from a few years ago that you know they took
in, and ask them about it. You'll only get two responses: either 'I
wasn't working that day' or chapter and verse on the job—who did
what, what chief was working, the goofball covering officer who
didn't know his ass, old Joe from so-and-so truck who went through
the floor, every detail. The real jobs make an impression on the brain
pan, that's for sure. I could damn near draw you a *floor plan* for every
job I've worked."

Eddie Sere, Rescue 3

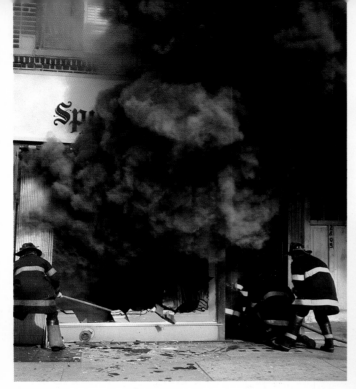

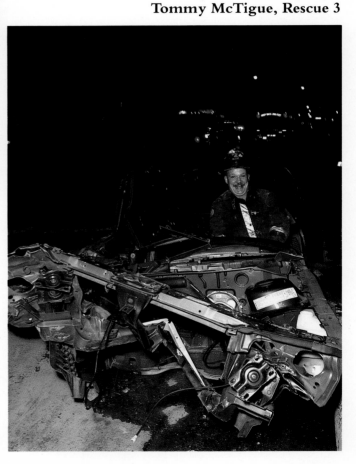

> We get a little crazy sometimes, but it's like a defense thing for your sanity—it's going to get you otherwise. I mean, just look at this goddamn dump. I'm not that old, and I can remember when this was a real nice neighborhood. God, what they've done to my city."
> **Tommy McTigue, Rescue 3**

> You always look at the color of the smoke as you roll in. Basic rule is, the darker the color, the more of a beating you're going to be taking. White smoke, that's mostly steam; somebody's already getting water on the fire. Nice tan color, that's wood burning. Black, look out—it's oil or something chemical, like the newer upholstery, urethane furniture or Naugahyde. That's the worst. Hard to believe that guys used to do this job without masks, and think nothing of it."
> **Lieutenant Don Hayde, 281 Engine**

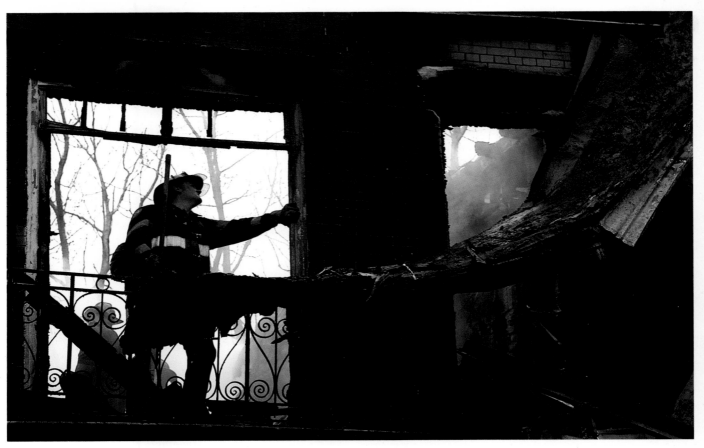

❝ These buildings, they break your heart. Ten, twenty, thirty
fires in some of these places, and they're still standing. You can
burn them out, but not down.

"They built these joints for the ages, let me tell you. They didn't call
this the Grand Concourse for nothing. I can remember visiting these
apartments as a kid in the forties, the fifties. The tile in the hall, the
varnished banisters, the chandeliers—for us kids it was like going into
a palace. Now look at 'em. Breaks your heart."

Pat Connolly, 38 Truck

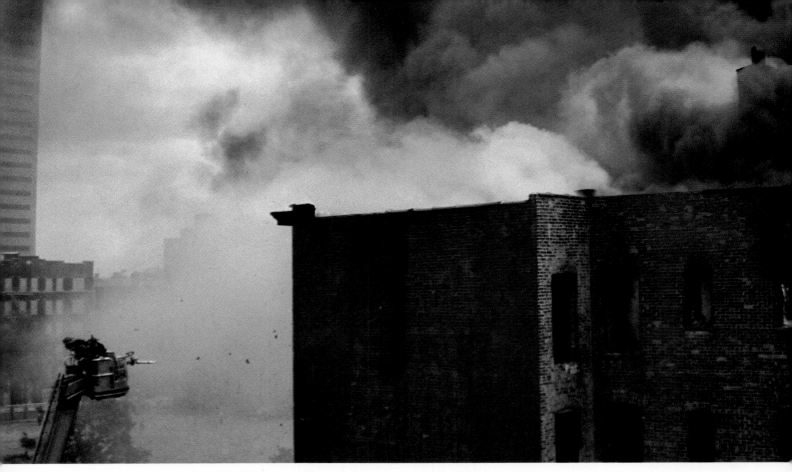

“ *We have heavy fire showing on floors four, five and six, extending into the cockloft. Structure is a six-brick, 75 by 100, occupied, with all occupants out at this time. Numerous rescues from primary search. Secondary search negative.*

“*Exposure one is the street; exposure two is a vacant lot; exposure three is the rear yard; exposure four is a six-brick vacant. Third engine is checking extension into exposure four. Two lines are in operation, and a third line is being stretched into the fire building. We have a tower ladder in operation on exposure one and a second setting up. Doubtful will hold.*”

Progress report from 18th Battalion, the Bronx

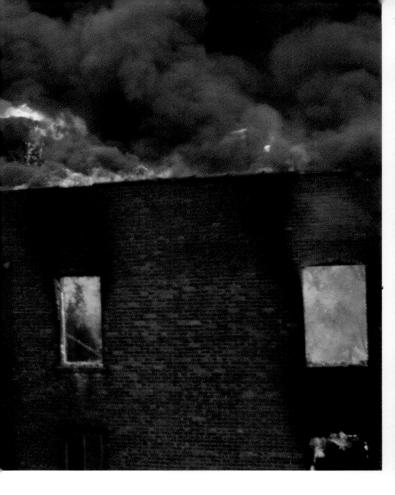

" Yeah, I remember the kid; he was real polite, and smart. He asked good questions about the rigs and the job. I've talked to press guys that couldn't ask a question as well as this kid. He's a diamond in the rough. You can't help wondering what will happen to him, growing up in this zoo."
Chief John McMahon, Battalion 14

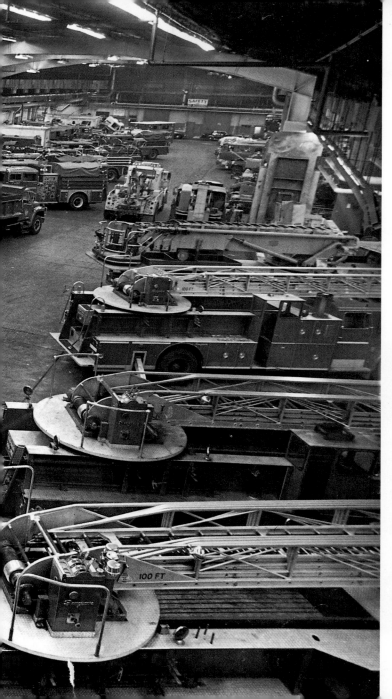

> " You get some idea how huge this department is when you look at the main shop floor. We're servicing about 3100 rigs a year in here. There are very few departments anywhere that have as much apparatus *total* as we have on the floor on any one day."

Chief Tom Halford

> " *Battalion four-one, be advised you're going in with two and two...four-one, we're now filling out the box, giving you the third engine, the squad, and Rescue 2, we're now receiving numerous phone calls, repeat numerous calls, reporting fire on several floors and occupants in the windows...*"

Dispatcher 269, Brooklyn Communications Office

❝ It's a job that's going to hurt people. You can only protect yourself so much. Most injuries are sprains, fractures, back problems and cuts. Not as many smoke and burn problems these days, with masks, and safer clothing, and safer operations at fires.

"Just a few years ago, we'd have 12,000 injuries a year requiring hospitalization—that's one per man per year. Today it's under half that. Still, whoever heard of a job where it's normal to get hurt every two years?"

Captain Richard Fanning, Medical Division

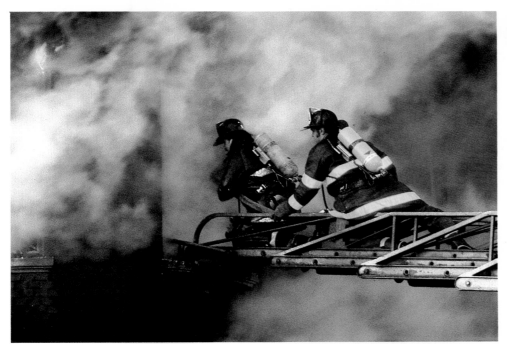

66 Most inside fire work, you do everything on radar—or should I say by braille. When you're searching, you crawl around feeling in front of you with your hands. You're completely blind. It's mainly the smoke, but the mask facepieces restrict your vision, too—they're not very well designed, and they're usually all scratched up. We're long overdue on this job for better breathing apparatus. You manufacturers out there listening?"

Dennis Gordon, 38 Truck

66 To get on the Rescue, you got to have an interview with the captain. Cap gives you the 'Magnet Test.' Big electric magnet in the ceiling. You have a metal plate in your head, you go up—BANG—and you hang there from the ceiling, you pass the interview and you're on the Rescue. That's the only way we made it. No kidding."

Chris Waters with Tommy McTigue, Rescue 3

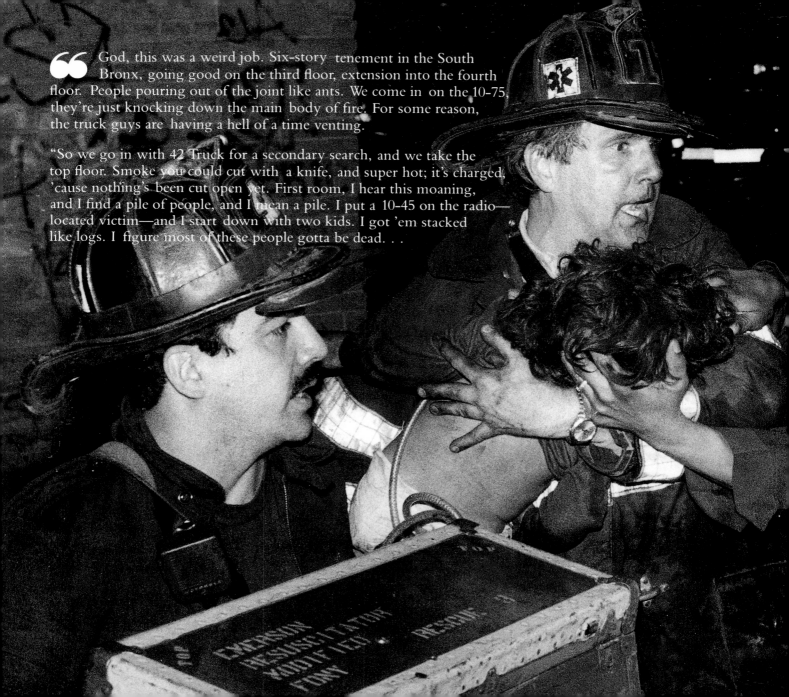

> **❝** God, this was a weird job. Six-story tenement in the South
> Bronx, going good on the third floor, extension into the fourth
> floor. People pouring out of the joint like ants. We come in on the 10-75,
> they're just knocking down the main body of fire. For some reason,
> the truck guys are having a hell of a time venting.
>
> "So we go in with 42 Truck for a secondary search, and we take the
> top floor. Smoke you could cut with a knife, and super hot; it's charged,
> 'cause nothing's been cut open yet. First room, I hear this moaning,
> and I find a pile of people, and I mean a pile. I put a 10-45 on the radio—
> located victim—and I start down with two kids. I got 'em stacked
> like logs. I figure most of these people gotta be dead. . .

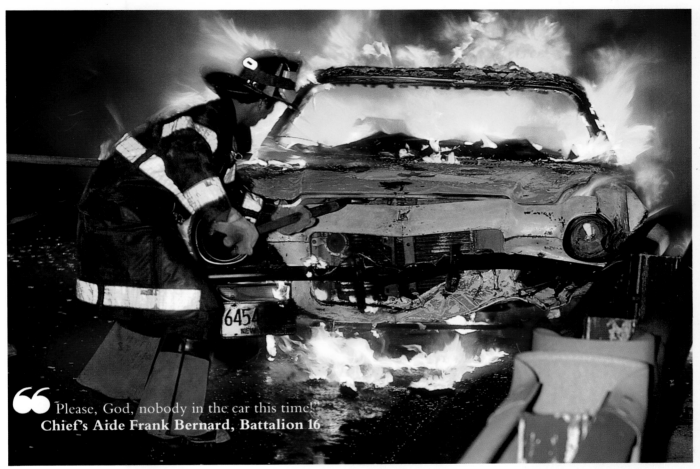

". . . Then I'm hearing the truckies on their radios, and the other rescue guys, saying, 'I got another one,' and 'I'm bringing down two.' We're all calling, 'Get the hell up here—we're tripping over 'em.' I get out front, no ambulances yet, and pretty soon they're laid out all over the street, with CPR and the resuscitators going. We put 'em in cop cars, the chief's car, to take 'em to the hospital. The worst thing I've ever seen—we figure they're all DOA.

"Anyway, we got about 18 people, mostly kids, and every one lived. I couldn't believe it. CPR is great on kids; they'll bounce back. Like that kid in Chicago, under the ice a half hour? Amazing. We earned our dough that night, if I do say so myself."

Pete Ferrante, Rescue 3

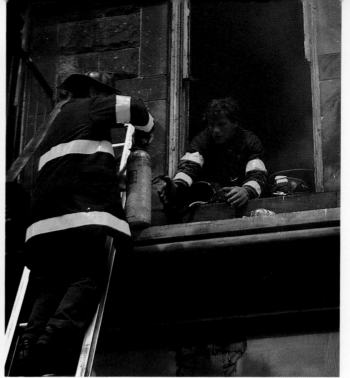

> **" "** These guys that like to talk about the good ol' days, they can have 'em. Not much nostalgia for the past on this job. Oh, yeah, we hang onto our leather helmets, and we bitch when they came along with green fire trucks. Although we kinda like ours now. But really the past was no masks, no facts about chemical hazards, people going through roofs like crazy, 15 and 20 guys a year dead on the job.

"I'll tell you what's changed the job completely, made the job much safer and easier. Three things: the air masks, the tower ladders and the Partner saws for venting. No, four things: the Handie-Talkies. What the hell did we ever do without the radios?"

Lieutenant Sal Caliendo, 58 Engine

"Get out, you miserable cowards,
the Bronx is burning, everybody goes!"
House watch, 88 Engine/38 Truck

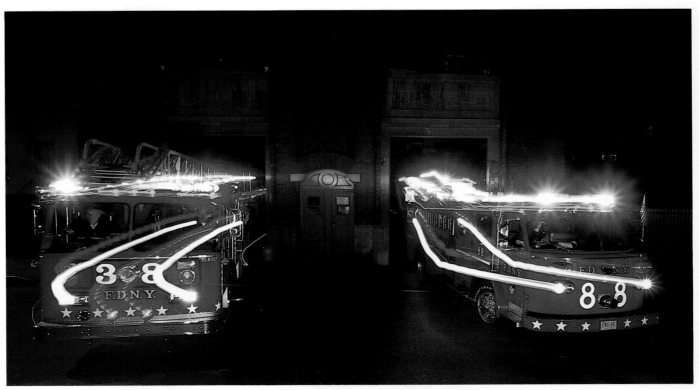

" While trying to get, and keep, a firm grip on the frantic civilian it was also necessary for Fr. [firefighter] Konrad to swing back between the windows and maintain that position on the way down. He and the civilian were then swiftly lowered past the blazing fourth and third floor windows to the safety of the courtyard below."

"With fire mercilessly stabbing out at them, Fr. Connolly opened his coat and clutched the child trying to protect her."

"...the walls were cherry-red and on the verge of collapse. Glancing over his shoulder, Fr. Ostrander saw a huge ball of fire rolling at them."

"As he dragged the victim through the kitchen, the ceiling in the bedroom collapsed and the entire room lit up as a result of the fire in the cockloft."

"He returned to lead the water attack without his mask and while suffering from burns endured during the earlier rescue."

"Crawling on his stomach dragging the oversize 200-pound woman backwards was a slow process, and the fire was beginning to engulf them."

"Lt. Pritchard, exhausted from the heat to the point of collapse, began crawling through the heat and smoke towards the sounds of the victims. Once he reached them he found Lucy and Julio Flores struggling to get their retarded, 230-pound son to the kitchen window. The Lieutenant, almost completely spent, managed to get the three trapped people out the window onto a small overhanging ledge outside. After insuring they were safe, he went back to continue searching the apartment..."

**Excerpts from citations for valor,
Medal Day, June 6, 1984**

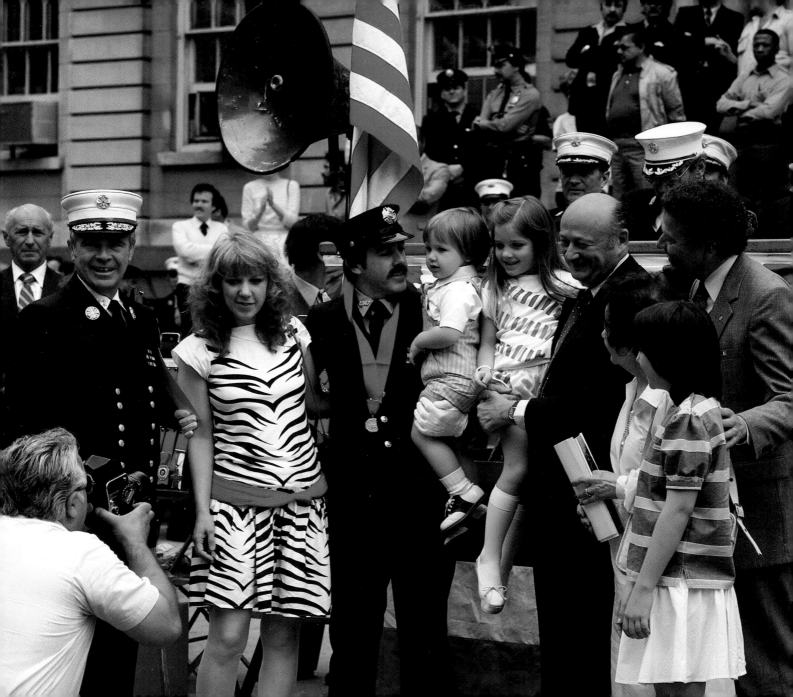

New York firefighters pay for their own meals and do their own cooking. Kitchen responsibilities are shared, and everyone is expected to knock out at least one meal now and then. Houses handle the cleanup and shopping duties differently; multi-company houses generally rotate the chores monthly between engine and truck.

Naturally, some cook better than others—some *enjoy* cooking more than others—and most stations let their superstars do the serious work. There are hundreds of superb chefs scattered about the FDNY, many with professional experience and highly sophisticated skills under their belts. Arguably the best cook of the lot is John Senino, late of Harlem's 58 Engine, currently a commissioner's driver. He frequently returns to his old base, "The Fire Factory," to regale the evening tour with his latest creation.

On this occasion, it's veal pizzaiola, mostaccioli with pesto, Italian green beans and the notorious Senino piña colada cheesecake X-23 ("still in the experimental stage after 23 modifications," explains Senino). Fire Commissioner Joe Spinnato conveniently dropped by the house at mealtime to press the flesh and check on unit morale....

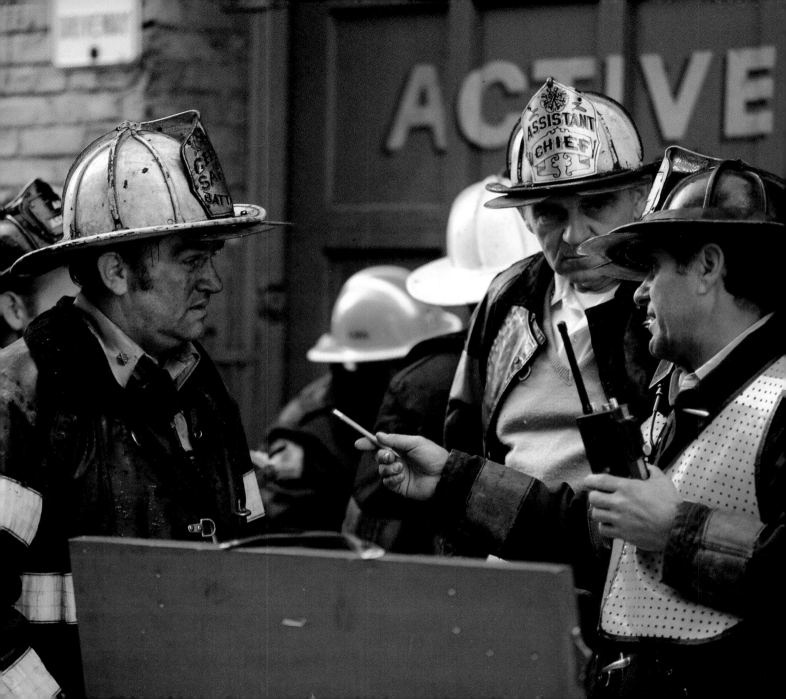

Radio

The New York City Fire Department pioneered radio dispatch in the thirties with a crude but reliable low-frequency AM system (call letters: WNYF) linking headquarters with the FDNY's 10 fireboats and remote Staten Island companies. Successful experiments continued with cumbersome two-way setups in chief's cars and Manhattan's rescue company. Peerless fire buff Fiorello LaGuardia soon had a similar system, complete with wobbling nine-foot antenna, in his official mayoral Cadillac.

Fifty years later, FDNY companies respond nearly a thousand times a day, on everything from single-engine nuisance calls and false alarms to rip-roaring fifth alarms. A spectacular computer-aided dispatch system called "Star-

Field Communications officer, right, huddles with borough commander and safety chief at Harlem fifth alarm.

fire" links communications offices ("COs") in the five boroughs and within seconds assigns the closest units to the incident.

Every one of the city's millions of addresses is keyed in the computer to the nearest alarm box, of which there are some 16,000. The alarm will be transmitted by box number, regardless of its origin: ERS (the Emergency Reporting System boxes, which permit citizens to talk directly with fire or police dispatchers), manual pull box, telephone call, a knock on the firehouse door, or whatever. The street boxes give Starfire the instantaneous location for the incident; phone-ins require that the address be entered manually into the computer.

The computer screen comes alive with a flurry of information: units due at the box on first through fifth alarms, nearby street box numbers, relocation suggestions, cross

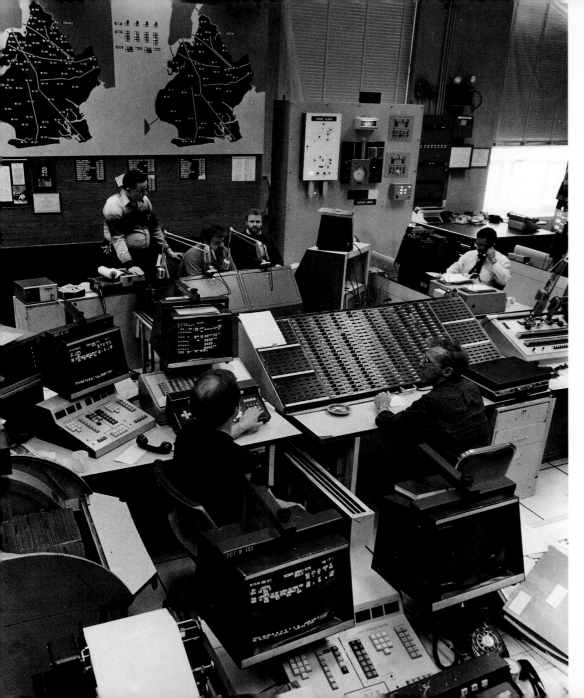

Interior of the Brooklyn Communications Office.

streets and so on. Armed with this data and the ongoing activity in the borough, the supervising dispatcher will send out the assignment to the stations. In most cases, the dispatcher will side with Starfire's recommendation. But he has the option of sending, say, a single engine and truck to a likely false alarm, or a brace of extra companies if numerous phone calls are pouring in.

The dispatchers are civilians rather than firefighters, but their knowledge of the borough and the best response for any situation is uncanny. It's a job that calls for experience, judgment, decisiveness and, above all, a cool head.

A typical dispatch, in response to a phone call reporting a structure fire, will put two engines and two trucks on the street. Tapping the four appropriate buttons on the computer keyboard will sound tone alarms in the stations, while high-speed printers bang

Computer screens reveal details of working fire in Brooklyn. *Progress report from battalion chief's aide is displayed on screen.*

out the address and other information for each company officer to take along in the rig. A touch of a button on the station printer signals the dispatcher that the alarm has been received and the companies are heading out the door. The whole process — from the first ring of the phone to the rigs roaring into the street — takes about a minute, day or night.

As the companies are rolling, radio announcements repeat critical information and advise the responding units of additional facts or companies being assigned. If the units due are "10-8" (on the street and on the radio, rather than waiting in quarters), the voice announcement will be their only notification of the incident. Each company will be asked to acknowledge, and a series of shouted "10-4's" will be transmitted over yelping electronic sirens.

The basic two-and-two response can be augmented to virtually any level by the dispatching staff, either in response to the pulse-pounding "10-75" (fill out the first-alarm assignment) from the first-arriving engine or from an instinctive assessment of incoming phone calls. Ace Brooklyn dispatcher Ken Fisher recalled, "We once sent five engines,

five trucks, Rescue 2, the squad, several chiefs and I forget what else on a single phone call. But that was one quality call, believe me. There's a tremble in the voice that no actor can fake, and when you hear it, you hear it." Eight people died in that tenement blaze, but 40 others were rescued in minutes, and the Brooklyn CO staff was thanked personally by many responding firefighters after that 1982 job. "I'll always roll the extra companies if there's even a little bit of doubt. Better too many guys than not enough," Fisher said.

When several nearby incidents of a large multiple-alarm fire strips part of the city of its fire protection, dispatchers will relocate other companies temporarily to even out the coverage. Again, Starfire will recommend the best relocation scheme, and the units will then move across town to the empty houses of the companies involved. The "covers" will usually stay in the firehouse even after the home team returns, so they can reorganize their gear, change air bottles, get into dry clothes and "take a blow."

FDNY radio transmissions emanate from communica-

Radioman inside Field Comm van at greater alarm.

on 154.40 MHz, with the Bronx and Staten Island sharing the 154.19 MHz channel. In addition, a city-wide channel, 154.43 MHz, carries announcements of all-hands fires and additional alarms in all boroughs, as well as the less interesting administrative chatter and traffic for the department brass. There is a rarely a moment, day or night, when something isn't going out on at least one of the channels.

Transmissions from vehicles are rebroadcast over the borough channels by repeaters or "mixers," so that every unit can hear every other regardless of intervening distance or buildings. Most FDNY Motorola mobile radios run a powerful 25 watts or more; their signals can penetrate clearly even from the steel canyons of Midtown Manhattan. Satellite receivers are scattered around the city on each channel to ensure that each field unit has a clear shot at one or more. After the initial dispatch of an incident, the first-in company will report "10-84" (arrived at the box) to the "radio-in" dispatcher, who will record the times of all transmissions from that point onward, forming a computer-filed incident record. This can be invaluable if disputes arise as to when the fire department got to the job and exactly what they did when they got there.

At a 10-75 or other major incident, the aide to the first-arriving battalion chief will set up shop as the radio link to the CO. If additional alarms are transmitted, a field communications officer will respond from his Brooklyn base; he then takes charge of all signaling responsibilities. Progress reports will be radioed at regular intervals, describing the fire building, its surroundings, and the efforts of companies to control the fire. A pessimistic "doubtful will hold" report, indicating that things are getting worse instead of better, will probably be followed by a request for more companies or yet another alarm. All these transmissions, including ominous "10-45s" (discoveries of dead or unconscious victims in the building), will be recorded and timed for later review by the radio-in dispatcher.

Details of arson investigations or injured firefighters are not transmitted from the fire scene without a "mixer off" request. The dispatcher will then switch off the repeater

tions offices in each of the boroughs, with overall control residing in the Manhattan shop deep in Central Park. The powerful VHF signals can be recieved all over the New York metropolitan area on widely available scanner receivers from several manufacturers. (Bearcat, for example, offers a line of scanners with list prices ranging from $100 to $400.) After a few hours of practice, listeners will learn the terms, rhythms and code signals; ears will become attuned to little tip-offs that lead into the big burners.

Manhattan incidents are handled on a frequency of 154.25 MHz, Brooklyn on 154.37 MHz, and Queens

system so that the transmissions of the units in the field will not be rebroadcast around the city. There is an understandable reluctance to put out name-naming details on the air; it would be a hell of a note for a firefighter's family to learn of his injury or death via his home scanner.

By far the most exciting listening takes place on the 153.83 MHz tactical channel. Every engine, truck and rescue company arrives with several Handie-Talkie portable radios. These radios are used to communicate all around the fireground among enginemen on the nob, truckies venting the roofs or searching for victims, chiefs and their aides, arson marshals and other special-called units. The aide at the command post keeps one ear to his portable and the other to the vehicle link to the CO, relaying progress information and requests for further assistance. This fireground channel is not repeated citywide, so listeners can usually hear the tactical chatter only within the immediate vicinity of the fire.

To the new listener, FDNY radio sounds like a continuing apocalypse. But like most public service communications, the vast majority of dispatches turn out to be routine or uneventful: "10-33" (odor of smoke, almost never a real fire), "10-22" (outside trash burning), "10-37" (assist a civilian) and, over and over, the demoralizing and maddening "10-92" (malicious false alarm). Listen for the clues to the big burners: a dispatcher's decision to fill out the box, usually indicating a rush of phone calls or street boxes (and usually followed by a "numerous phone calls" announcement on the air), a shouted "10-75" from the first-arriving company, the predawn box in a trouble-prone neighborhood. And stay tuned for the most exciting tip-off of all: *the dispatcher's tone of voice.* The men and women on FDNY radio are experienced pros who have heard it all, but when the phones light up with frantic reports of a huge blaze, they can't help communicating this urgency on the air. It's a difficult phenomenon to describe on paper; suffice it to say that you'll know it when you hear it.

Emergency Reporting System (ERS) street boxes are gradually replacing older pull boxes throughout New York. The boxes permit citizens to talk directly with fire or police dispatchers. Box signals followed by silence or nuisance comments can be ignored by dispatchers; if a determination of the problem cannot be made in five seconds, a single engine will be sent to investigate. Most other situations—ranging from a good verbal report to confused shouts or a torrent of foreign words—will elicit a full two-and-two response. False alarms remain a problem with ERS boxes, but far fewer units are dispatched.

FDNY Radio Code Signals

10-1 Call your quarters (or other unit, if so instructed).
10-2 Return to your quarters.
10-3 Call the dispatcher by telephone
10-4 Acknowledgement.
10-5 Repeat message.
10-6 Stand by.
10-7 Verify address.
10-8 In service by radio.
 Without Code,
 Code 1
 Code 2
10-9 Off the air.
10-10 What is your location?
 Ascertain the location of.....
10-11 Request for radio test count.
10-12 First arriving unit, give preliminary.
10-14 Breakdown of apparatus.
10-18 Return all units except engine, (squad) and ladder company required at the scene.
10-19 Return all units except company required at the scene.
10-20 Proceed to box location at reduced speed

PRELIMINARY REPORTS — FIRES

10-21 Brush Fire.
10-22 Outside rubbish fire.
10-23 Abandoned/Derelict Vehicle Fire.
10-24 Auto Fire.
10-25 Manhole or Transformer Vault Fire.
 Code 1 a. Manhole fire extended to building(s).
 b. Gas main leak.
 c. Uncontrollable gas leak in structure.
 Code 2 Blown manhole cover(s) or smoke issuing under pressure. F.D. standing by.
 Code 3 Smoke seeping from manhole—condition less severe than Code 1 or 2.
 Code 4 Building fire extends to Main Fuse Box.
10-26 Food on stove.

PRELIMINARY REPORTS — EMERGENCIES

10-31 Clogged incinerator.
10-32 Defective oil burner.
10-33 Odor of smoke (includes nearby working fires and friendly fires, such as barbeques, salamanders, etc.).
10-34 Sprinkler malfunction.
10-35 Defective alarm system.
10-36 Auto Emergency.
 Code 1 Accident and/or washdown. Gasoline spillage.
 Code 2 Accident. No Gasoline spillage.
10-37 Assist Civilian (applies whether or not F.D. related).
10-38 Steam leak.
10-39 Water Condition.
 Code 1 Water leak in structure.
 Code 2 Broken water main in street.
10-41 Incendiary or Suspicious Fire. Notify Fire Marshal.
 Code 1 Occupied structure. Definite indications of incendiarism. Fire Marshal to respond.
 Code 2 Occupied structure. While no definite indications of incendiarism, witnesses and/ or other civilians have information that may be of value. Fire Marshal to respond.
 Code 3 Vacant building. Heavy volume of fire

indicates definite incendiarism. Fire Marshal to respond as other priorities permit.

Code 4 Vacant building. Obviously incendiary and it appears that there is very little chance for apprehension or obtaining information leading to same. Notification for Fire Marshal's evaluation.

10-44 Request for public ambulance.
10-45 D.O.A. or Possible D.O.A.
 Code 1 Victim deceased.
 Code 2 Victim possibly deceased.
 Code 3 Victim suffering serious injuries which may lead to decease of the person.
10-47 Request for Police.
Assistance (Specify).
10-48 Request for Police.
Assistance (Harassment).

NOTIFICATIONS

10-51 Cancellation of all outside activities for this period.
10-59 Water Pressure Alert - Phase I.
10-60 Water Pressure Emergency - Phase II
10-68 Restrict use of telephone, voice alarm and radio to absolute minimum.
10-70 In Line Pumping.

MISCELLANEOUS

10-75 Request for 3 engines (2 engines and 1 squad) 2 ladders, and a battalion chief response.
10-76 Request for the response of four engines, four ladders, one rescue company, two battalion chiefs, one deputy chief and the Field Communications Unit for a fire in a High-Rise building.
10-77 Request for the response of one additional deputy chief, two additional battalion chiefs, one additional rescue company, the High-Rise Unit, a command post company and the Mask Service Unit for a fire in a High-Rise building.
Note: As used herein for signals 10-76 and 10-77, the term "High-Rise building" includes all buildings over 100 feet in height except Class A multiple dwellings.
10-80 Hazardous Materials incident:
 Code 1 A hazardous material incident which involves a severe hazard or extremely large area and which will require expert assistance from specialized agencies.
An incident where evacuation may last for a prolonged time.
An incident where numerous civilians are injured or exposed.
 Code 2 A hazardous material incident involving a lesser hazard or a smaller evacuation area.
 Code 3 A hazardous material incident which can be controlled by responding units and the HMRT and does not require evacuation of other than the involved structure or immediate area if outdoors.
10-84 Announce arrival at box.
10-92 Malicious False Alarm.
10-99 Units will be operating for at least 30 minutes.
10-100 Restricted use of City Wide Radio frequency due to Hi-Rise Fire.

Glossary

AERIAL: A 100-foot hydraulically powered ladder, mounted on approximately half of the FDNY's trucks. Other trucks are tower ladders, with a bucket mounted at the end of a telescoping boom.

AIDE: An assistant to a chief. The aide drives the chief, handles paperwork and acts as the chief's eyes and ears at the fire scene.

ALL HANDS: A fire incident at which the entire first-alarm assignment is working.

BACKDRAFT: A sudden intensifying of the fire when an inrush of oxygen is introduced, perhaps by a window or door being opened. An often deadly threat. Also called an oxygen or smoke explosion.

BACK OUT: A command to retreat, to regroup in a safer place. Used sparingly, with the expectation that everyone will move with maximum haste.

BATTALION: A group of engine and ladder companies covering a given geographical district. The FDNY is divided into 12 divisions and 55 battalions, each commanded by a chief.

BOROUGH CALL: A fire that has gone beyond fifth-alarm status to require an influx of companies from neighboring boroughs. The Bushwick fire (below) required a borough call.

BOTTLES: Refillable air containers for the Scott Air-Pak breathing apparatus.

BOX: One of 16,000 alarm devices on New York street corners. All alarm assignments are referred to the nearest box number, even when the alarm comes in verbally or by phone.

CHARGED LINE: A hose-line with water coursing through it.

COCKLOFT: Common attic space under the roof. Fire reaching the cockloft often spreads laterally with devastating results.

CONFLAGRATION: A fire of such tremendous intensity that water streams have virtually no effect on it. The multi-block blaze that occurred in Bushwick, Brooklyn, in 1977 was a conflagration.

CPR: Cardiopulmonary resuscitation, a life-saving technique which keeps blood flowing and lungs working in a person who has suffered a collapse or cardiac arrest.

DIVISION: See BATTALION.

DRB: Discretionary response box, a street box which is so often false that it gets a reduced assignment at the dispatcher's discretion.

ENGINE: Firefighting apparatus which pumps water and carries hose.

ERS: Emergency reporting system, the heart of which is the street box with two-way telephone communication to police and fire dispatchers.

EVOLUTION: A predetermined firefighting maneuver with hoses, ladders, towers and other equipment.

EXPOSURE: Surface on adjoining buildings which may be liable to catch fire. A building adjoining a fire building is referred to as an exposure building.

FILL OUT THE BOX: A dispatch of the full first-alarm assignment, usually three engines, two trucks, a rescue company and two chiefs, in response either to a "10-75" signal from a unit at the scene or to the dispatcher's assessment of incoming phone calls.

FIRE: The rapid oxidation of gaseous, liquid or solid fuel in atmospheric air. *Flame* is the heat-producing, usually visible part of the fire.

FIRE BUILDING/FLOOR/ROOM: Where the action is.

FIRE LINE: Police boundary around a fire scene, which one cannot cross without permission or accreditation.

GREATER ALARM: A fire of second-alarm or greater assignment.

"H": A multi-story brick tenement apartment with centrally located air shafts, giving the building the appearance of a capital letter H from the air. Common in the Bronx.

HALLIGAN: The all-purpose steel prying tool invented by FDNY officer Huey Halligan.

HANDIE-TALKIE: The trade name for Motorola's portable, two-way VHF radios, carried by key personnel at fire scenes.

JAWS OF LIFE: More properly, the Hurst Forcible Entry Tool. This machine can cut or pry apart almost any material, and is most commonly used to extract injured motorists from wrecked vehicles. The tool is carried by most FDNY trucks and all rescue companies. Featuring a hydraulic pump powered by a small gasoline engine.

JOB: A working fire in FDNY lingo.

JOHNNY: A probationary or first-year firefighter. Also called probie.

JOINT: Any building — house, high-rise, store, parking garage, etc.

"K": "Over." Used on New York fire and police radio to denote the end of a message.

KNOCK IT DOWN: Hit and extinguish the fire with water.

LADDER PIPE: High-volume nozzle mounted atop an aerial ladder and controlled from the ground by lanyards.

MASK: Refers to the mask plus the regulator and tank of the Scott Air-Pak. It gives the firefighter up to 30 minutes of cool compressed air in a backpack tank.

MASTER STREAM: Water at high volume and pressure, directed through outside nozzles. Usually employed when inside firefighting efforts have proved unsuccessful or unnecessary.

MAXI-WATER: A system of several special rigs: high-output pumpers, high-pressure

pumpers and satellite rigs which carry heavy hose and large deck guns. Replaces the famous Super Pumper setup of the sixties.

NOB: The business end of an attack hose-line. Used regardless of the specific type of appliance employed: fog nozzle, brass tip, etc.

OVERHAULING: The difficult and dirty job of tearing apart walls, ceilings and floors in the fire building to look for lurking hot spots.

POMPIER LADDER: Named from the French word for firefighter. Also called a scaling ladder. A narrow ladder with protruding pegs for footholds and a 90-degree steel hook used for hanging the ladder on a window ledge. Dangerous to use and rarely employed except as a confidence-building device in training.

PROBATIONARY FIREFIGHTER: A new firefighter still in his first, carefully supervised year on the job. Also called probie, johnny.

QUEEN ANNE: Wood-frame dwelling of Victorian antecedents, common to large areas of Brooklyn. Not many left; unlike brick buildings, they seldom burn more than once.

RAILROAD FLAT: A type of tenement or row-frame apartment with long, narrow units, usually two per floor on either side of a long hallway. Difficult and dangerous to search, as they have exits at only the two ends.

RED CAPS: Fire marshals assigned to patrol areas with serious arson and false alarm problems. So-called because of their only identifying uniform, a red baseball cap. The Red Cap program has been enormously successful in deterring fire-related crime in New York.

ROCK, THE: The FDNY training and safety center located on Randall's Island in the East River.

SATELLITE: Part of the FDNY's Maxi-Water system, this rig carries large-diameter hose, connecting manifolds, and the huge Intelligent deck gun, which can put out up to 4700 gallons per minute. Also carries foam gear.

SEAT OF THE FIRE: The fire's point of origin. The effort is made to attack the seat of the fire whenever possible.

SPECIAL CALL: A request from the fire scene for companies or apparatus not normally assigned to the box.

STANG: A brand name of high-volume nozzles used throughout the FDNY. Each engine carries either a Stang or an Akron Ground-Hugger appliance, which can put out a large stream either from its usual position atop the rig or from a remote location on the ground or an adjoining building. Often incorrectly referred to as a "multiversal" after another brand of high-volume appliance used into the early sixties.

SQUAD: A unit of extra manpower operating on a pumper, which responds in areas with a heavy work load. Today, only one FDNY squad, in Brooklyn, remains on duty.

STILL ALARM: A call to check an extinguished fire, usually for insurance reporting purposes.

TAKE A BLOW: Universal firefighting talk for taking a rest or break; literally it's a "blow" of fresh air.

TAKE IT IN: Respond to a call. Companies on the street, returning to their quarters from an incident, often badger the dispatchers to be included in a developing job. They wait anxiously for his official OK: "Engine so-and-so, take it in."

TAKE UP: The order to collect gear and leave the fire scene. Music to a firefighter's ears on a cold, wet winter day or after hours of sweaty overhauling.

TAXPAYERS: FDNY lingo for low-rise, commercial row buildings which share a common cockloft. Taxpayer fires can turn into nightmares if the fire succeeds in spreading laterally through the cockloft.

TENEMENT: An all-purpose term for New York's multistory apartment buildings. Old-Law tenements, built before 1929, lacked fireproof floors over the cellar, and horrible fatal fires often resulted. New-Law tenements, ranging from six to nine stories, are constructed of brick with wooden joists and floors, and usually feature H-shaped air shafts mid-building. Some Old-Law tenements still lurk in Harlem.

TILLER: The steer-from-the-rear position on tractor-trailer ladder trucks, manned by a specially trained tillerman. Generally, the FDNY is moving toward fewer tillered aerial rigs and more non-articulated trucks.

TRUCK: Fire apparatus which carries ladders, forcible entry equipment and other heavy gear. The FDNY uses three basic types of trucks: tractor-trailer aerial ladders with tiller-steered rear wheels, non-articulated rigs with rear-mount powered aerials and tower ladders with a bucket at the end of a telescoping boom.

TURNOUT: Old-time firefighters responded to the call, "Turn out!" Today the term refers to the rubber or Nomex overcoat worn in proximity to the fire.

TWO AND TWO: The FDNY's basic assignment in response to the report of a fire incident: two engines, two trucks.

WORKING FIRE: A true fire incident, with obvious or visible flame. The radio signal "10-75" is actually a request to fill out the full first-alarm assignment to the box, but it is often used to report a real fire, as in, "We have a 10-75 at this box."